picture this

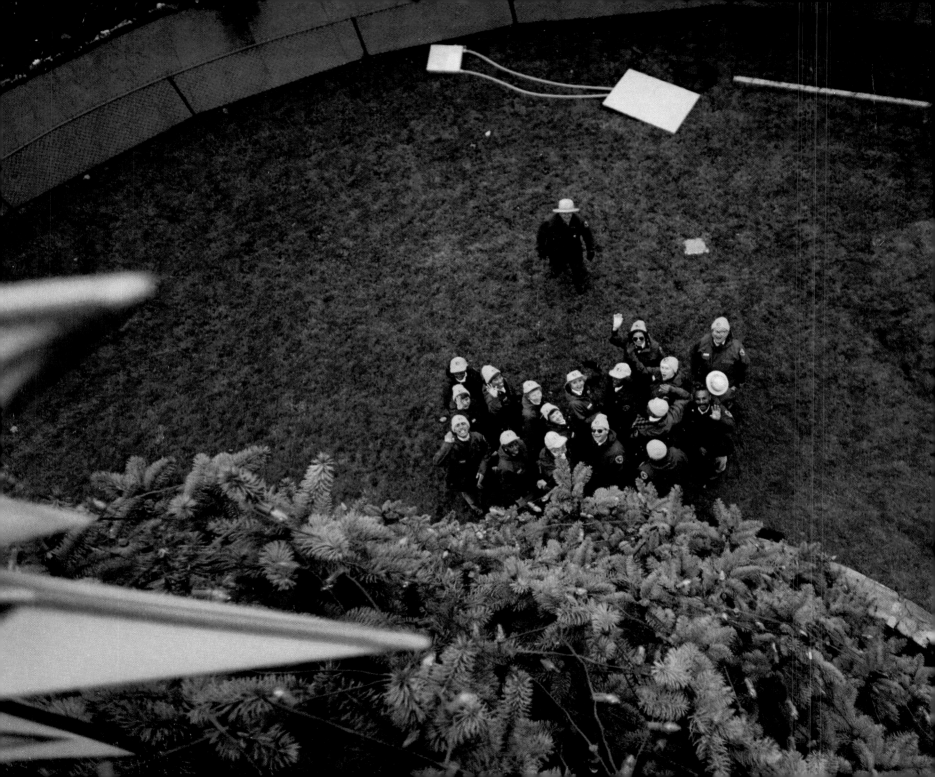

picture this

A Visual Diary

TIPPER GORE

broadway books

New York

FRONTIS: A unique perspective. I took this photograph from the top of the national Christmas tree on the Ellipse in Washington. I'm standing in a cherry picker.

PICTURE THIS: A VISUAL DIARY

Broadway Books titles may be purchased for business or promotional use or for special sales. For information, please write to: Special Markets Department, Bantam Doubleday Dell Publishing Group, Inc., 1540 Broadway, New York, NY 10036.

Grateful acknowledgment is made to the following for permission to use these photos: *page 1:* Phil Humnicky, offical White House photo; *page 7:* photo by Charles Guggenheim; *page 12:* Callie Shell, official White House photo; *page 16:* photo by Sarah Gore.

Library of Congress Cataloging-in-Publication Data
Gore, Tipper, 1948–
Picture this : a visual diary / by Tipper Gore. — 1st ed.
p. cm.
ISBN 0-553-06720-6 (hardcover)
1. United States—Politics and government—1993– —Pictorial works. 2. Gore, Tipper. 1948– —Pictorial works. 3. Gore, Albert, 1948– —Pictorial works. 4. Clinton, Bill, 1946– —Pictorial works. 5. Clinton, Hillary Rodham—Pictorial works.
I. Title.
E885.G66 1996 96-10709
973.929—dc20 CIP

FIRST EDITION

Book design by Marysarah Quinn

96 97 98 99 00 10 9 8 7 6 5 4 3 2 1

To all photojournalists with the courage and vision to
capture images that shed the light of truth

To the countless people who wake up on any given day
without a home

And to all the very special people who devote their lives
to helping those who are homeless

Table of Contents

The Making of a Photographer

People never quite know how to introduce me. Sometimes they call me the Second Lady. Sometimes they refer to me as the Second First Lady. Once I was even introduced as the Second Lady of Vice. Maybe no one has ever given the wife of the Vice President of the United States a title because the position itself is so poorly defined. There's no job description, no pay, no career path—and limited opportunities for promotion. The way I see it, this post is an opportunity to further the causes I believe in.

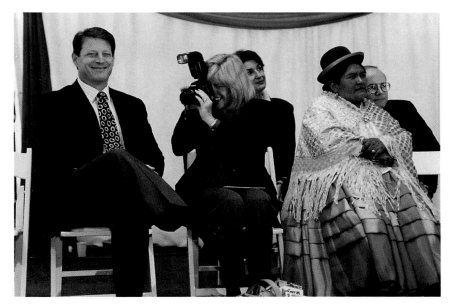

In that respect, my life now is not so different from what it used to be. For years I've been advocating better treatment for those with mental illness, for people who are homeless, and for children generally. The main difference is that as the wife of the Vice President, my voice on behalf of these communities has a broader reach. My priorities are the same too: my husband, Al, and our four terrific children come first. In other ways, though, my life has changed radically since Bill Clinton and my husband won the 1992 election.

People are always asking me what it's like to be the wife of the Vice President. Most of the time, it's incredibly exciting. One day I'll find myself in Saint Petersburg, opening a new center for the preservation of Russian art. The next, I'll be on horseback in the desert in Egypt, photographing the pyramids. Sometimes I have to pinch myself to make sure it's real. I have also visited with flood survivors in Winfield, Missouri, comforted firefighters who lost comrades on Storm Mountain in Colorado, and delivered a mental health lecture at Louisiana State University in New Orleans.

When I'm feeling something intensely, or I know that I'm witnessing a significant moment, I often

reach for my camera. These past four years have been so inspiring that I've taken more photographs than ever before in my life. Partly, I've been motivated by the unique vantage point I have on history—standing in a receiving line with Lea Rabin and the wife of Yasir Arafat before the signing of the Middle East Peace Accord, for example, or watching the Reverend Jesse Jackson introduce Winnie Mandela to Hillary Clinton at the inauguration of Nelson Mandela. But sometimes it's just the sheer novelty of the scenes I am witnessing, like seeing a dog sniffing for bombs in our new Residence.

Since the 1992 presidential campaign, I've shot hundreds of rolls of film, recording special family moments, important public events, and my travels around the United States and abroad. I look for the picture that tells a story—two old men gossiping in a marketplace in Marrakech; a bride and groom embracing in a public square in Saint Petersburg; Al, lying flat on the floor in the presidential palace in Pretoria, getting tips on back exercises from Hillary Clinton. I've also recorded some memorable family moments, like the day our daughter Kristin went off to college.

This book is a visual diary of the past four years, and, like any diary, it is highly idiosyncratic. What I've put in, what I've left out, and how I see events says as much about me as it does about the subjects I've photographed. As you'd expect, many of the photos have some connection to the administration or my family; some of them, however, relate to other parts of my life, like the one of my homeless friend Jack. I hope that for the most part, the photos speak for themselves. But maybe a bit of background about me and my love of photography will help explain why I wanted to bring together these pictures and these stories in a book.

The role of photography in my life has taken time to evolve. In my twenties, I was trained to use a camera as a tool for communication, a task for which photography is of course superbly well suited. For example, a picture I took recently of three adorable toddlers in Haiti who are well nourished thanks to a U.S. Agency for International Development program is—to me, anyway—worth at least the proverbial thousand words. But over the years, I have come to appreciate photography even more as an art form and a means of self-expression. It's not easy to capture an image that has the power to evoke complex feelings. When I do, it's tremendously satisfying. Finally—and most importantly, perhaps—photography is a way of keeping alive the part of myself that is not shared with anybody else. Inevitably I am a lot of different things to different people. I am a mother to four children. I am a wife. I am a daughter and a daughter-in-law. Also I have my official role in the administration and my volunteer roles. But the one thing I have engaged in and loved that is completely

separate from any of those other pursuits and people is photography.

When our first child, Karenna, was born in 1973, Al was working as a journalist on the night shift at the Nashville *Tennessean*. During the day, he was attending first Vanderbilt Divinity School and then law school. Meanwhile, I was feeling the need to do something for myself in addition to staying at home with our baby. Al had given me my first real camera—a 35 mm Yashica—and he and Nancy Rhoda, a good friend and professional photographer, both encouraged me to take a course in photography. I commuted one hundred miles round trip to take a class with Jack Corn, the photo editor at the *Tennessean*, and learned everything from the principles of photojournalism to printing and processing pictures. I remember one assignment Jack gave us was to show that the person whose picture you are taking loves you. So I took a picture of Al shaving. He was standing in the bathroom, looking very handsome, with lather on his face, wearing the most intimate and loving expression. It's a picture I will always treasure.

Evidently Jack saw something in my work, because he offered me a part-time job at the *Tennessean*. I started out in the photo lab, developing film, and progressed to printing pictures and, finally, shooting them. After a while, I began doing photo essays, taking the pictures and writing the text. When the paper published them, it was a huge thrill. For

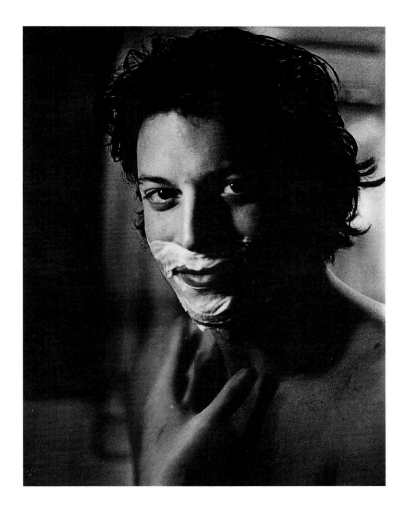

instance, the paper ran my picture of an evicted woman sitting in the rain; afterward, scores of people called in offering to help, reinforcing my growing understanding of the power of photography to inspire and motivate.

While working at the *Tennessean*, I was also going to graduate school, studying for my master's degree in psychology. I was planning to become a therapist, even though I felt more and more drawn to photography. And then Al dropped his bombshell. One Friday in March 1976, he told me he was thinking of running for Congress. At the time, I thought Al was going to become either a lawyer or a writer. But that very morning we learned that the seat of the Fourth Congressional District in Tennessee—the district where he grew up and where we owned a farm—was being vacated. Three days later he announced his candidacy, and our lives changed forever.

Al was raised in a political family. His father had served in Congress for many years, and Al had always been fascinated by politics. It was clearly too good a chance to pass up. Though I understood his decision, my feelings about it were mixed. I had just attended a seminar on photography in Atlanta, and I was eager to keep on learning. I was as happy as I had ever been—I loved taking pictures for the *Tennessean*—and at first I said I would only campaign for Al on my days off. But Jack Corn talked some sense into me. "Tipper," he said, "this is the chance of a lifetime. I think Al can actually win, but you really need to get out there and work with him. And don't worry. If he does lose, your job will still be here."

Part of my reluctance, I suppose, came from not wanting to be totally swept up in Al's life just at the moment when a professional career of my own was

beckoning. But Al and I had operated as a team since the early days of our marriage, and there was no way I could feel comfortable doing anything but wholeheartedly supporting him at this important moment in his life. We had meant too much to each other for too long.

Unfortunately, I was not what you would call a natural politician. Even though Al's father, Albert Gore Sr., had been in the Senate for many years, and even though I had helped in his last campaign some years earlier, it was agony for me to go up to strangers and ask them to vote for my husband. I could be embarrassed very easily too and had to work to become comfortable in my role of a political spouse. Once a man demanded I name all twenty-five counties in the Fourth Congressional District. Today, I would recognize a question like that as abusive and handle it appropriately. But in those days I was very green and had to learn the ropes.

Soon after Al's first campaign got under way, Jack Corn suggested that I try to document it with my camera. But I couldn't do it. I was too distracted by the conflicting roles of participant and observer. Both campaigning and taking pictures require wholehearted commitment and concentration.

Again, it was a question of priorities, so for the next few years, photography took a backseat to other things, mainly my growing family. Sometimes I missed the pleasure of taking a good photo. But for a number of years I was so busy that it rarely occurred

to me to reach for my camera. Besides, nothing is forever, and I always knew I could resume taking pictures one day.

Family has always been supremely important to me. Al and I both came from very small families, and early on we agreed that we wanted six children when we got married. Al grew up living part of each year on a farm in Tennessee and part in a hotel in Washington while his father was in Congress. His older sister, Nancy, to whom he was very close, was ten years his senior and too old to be a true playmate. I was an only child, and my parents were divorced when I was four.

After the divorce, my mother and I went to live with my grandmother and my grandfather, who was a banker. I adored them, and they adored me. They were the first to call me Tipper—my given name is Mary Elizabeth—a nickname that comes from a lullaby my mother used to sing to me. I certainly didn't lack for attention with all those adults doting on me. I also remained close to my father and his family, who lived nearby. But I envied my friends who had brothers and sisters to live with.

I grew up in a religious household where personal morality mattered a lot. I went to Sunday school every Sunday, attended Bible school in the summer, and was sent to an Episcopal girls' school that had chapel three times a week and taught religion as a required course. I am still religious today; officially, I'm a Baptist, although my beliefs are more or less nonsectarian. To my mind, the tenets of many faiths are valid, each in its own way.

Looking back, I think I was a pretty good kid, although I had a stubborn, rebellious streak—one that still emerges from time to time. I was also fun-loving and athletic. In high school, I was captain of the field hockey team and played basketball and softball; a friend and I were the badminton champions of our school. I also got a big kick out of playing the drums in an all-girls' band. We called ourselves the Wildcats, a name inspired by my mother's black Buick.

Without question, the big event of my youth was meeting Al. I was sixteen, he was seventeen. We were introduced to each other at his high school graduation dance, and he called the next day to invite me to a party that weekend. I'll never forget it: we put on a record and danced and danced. It was just like everyone else melted away. And that was it. We've been together ever since.

We both went to college in the Boston area. He went to Harvard, where he studied government. Not long ago, I was going through some old letters from him when he was a freshman at Harvard and I was still in high school and planning to visit him in Cambridge. The problem was that my grandmother

planned to come along as a chaperone. "Does she really have to come?" he asked. "I just want to be with you." But my grandmother came all the same, and Al behaved like a perfect gentleman.

I got a degree in psychology from Boston University, and that spring, after I graduated from college, we got married. Our wedding, at the National Cathedral in Washington, was traditional in some respects. I wore a white peau de soie gown trimmed in Alençon lace and beaded with pearls. Al's old headmaster at Saint Alban's Episcopal School, Canon Charles Martin, married us. But we had to get a special dispensation from the church for one of Al's friends to be able to play a medley of Beatles songs on the organ. The recessional was "All You Need Is Love." It was a great wedding.

That was twenty-six years ago, and I can honestly say Al and I are still in love—now more than ever. We share many interests, such as our concern for the environment and our desire for a deeper spirituality in our daily lives. We both like physical activity and being out-of-doors; whenever possible we run together. We're avid moviegoers, and we love jazz and rock 'n' roll, but neither of us is a big party-goer.

Good marriages don't just happen, of course. They take a lot of love; they also take work. You need to use ingenuity and creativity, and you have to have

a sense of commitment. When things are tough, you work them out; you don't cut and run. Carving out time for the two of us is a challenge because we're both so busy. When we do get some free time, we

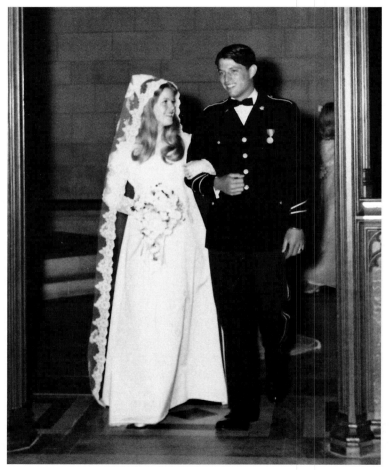

Wedding Day, May 19, 1970.

usually spend it with the children. But not always. I remember a little note in my stocking a few Christmases ago that said, "A weekend away, just for you and me." And one of the sweetest things Al did was to take me to Hawaii on our twenty-fifth anniversary in 1995. It's where we went on our honeymoon. Naturally, the kids suggested that we take them along, but he said no. We were only there for four days, but we bodysurfed and hiked the Na Pali Coast and had a glorious time.

I believe the secret to the success of our marriage is the way we view each other as partners. Al has supported me in everything I've undertaken. I've done the same for him. When he was in Congress, for example, I could have begun pursuing my own professional ambitions again. I have lots of friends whose husbands are in the Senate and the House who have their own full-time careers. Although they may go to an occasional luncheon for congressional spouses or a White House Christmas party, that's about as involved as they get in their husbands' political careers, and I respect their choices. But right from the beginning, Al wanted me to go with him on that journey in his life, so I plunged right in. It was a great opportunity to put some of my social concerns into action. Working with congressional friends, for example, I formed a task force to study violence on television and its effects on children. We issued a report and delivered it to Congress.

If anything, the experience of Al's being Vice

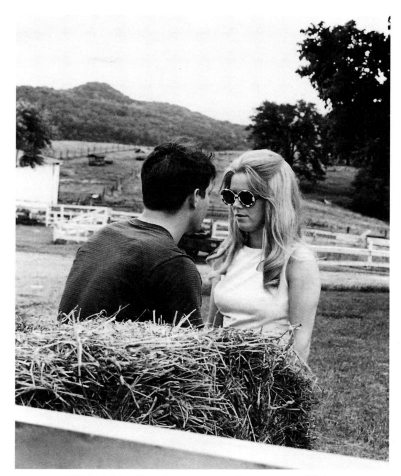

With Al in Carthage soon after our wedding.

President has made us even closer. We have shared so much, so intensely, over the past four years—the campaign, the inauguration, the great responsibilities the President has placed on Al's shoulders—that it's

best performed by a couple—a husband and wife, each with a role to play.

The other great thing about his job is that even though he works harder, he's home more. That's because when he was in the Senate, there were a lot of night sessions, and his schedule was totally unpredictable. As Vice President, he is more in control of his own calendar. Sometimes he still works at night, but his office at the White House is only fifteen minutes away from the Vice President's Residence, so he gets home for dinner a lot more often.

Best of all, he's often home on weekends now. When he is in Washington on Saturday and Sunday, he usually doesn't go to the office unless there is a crisis of some kind. We still don't lead what you would call an active social life, but now we can do things with the kids or each other on a Friday or Saturday night.

Al on vacation in the early 1980s.

I'm sure almost every mother feels this way, but I have been blessed with truly wonderful children. Karenna, who is twenty-three, graduated from Harvard last year and is spending a year working in Europe. Kristin is nineteen and is a sophomore at Harvard. Sarah is seventeen, and Albert is thirteen. It's not just that they are all good students and athletes. They are also very considerate and loving, to each other as well as to us. I've had baby-sitters and friends tell me for years how remarkable it is that the

deepened the intimacy between us. There is more of a sense of unity to our work life too. Some of the ceremonial duties that come with Al's job are duties

children get along so well and almost never fight. I thought it was just normal behavior!

From the start, I loved being a mother. I even loved being pregnant and think that giving birth is such a fantastic experience. And Al turned out to be a marvelous father. I'll never forget how awe-struck he was when Karenna was born. He held her as if she were a precious jewel. We had read a lot of books in preparation for her birth, including one that said newborns could register a considerable amount of sensory input. I remember watching him hold Karenna up to the roses he had sent me, trying to test whether or not she could smell.

When I came home from the hospital, he took his week of vacation time to take care of me. I still have to laugh when I think of it. He has never been one for cooking, but for breakfast, he decided to make me poached eggs, and he cracked them open and boiled them in a lobster pot! And he just let the dishes stack

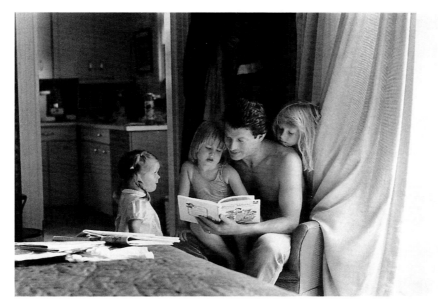

Al reading to our young daughters in 1980.

up until one night a friend of ours came over and washed them all. I kept feeling like I was in the middle of an *I Love Lucy* episode.

He's always been a very affectionate father and enjoys imparting knowledge to the kids. We both try to do things individually with the children so that we don't relate to them only as a group. I'll take them on a biking trip. Al will take them to visit a museum. He's taken Sarah three different times to the Holocaust Museum, for example, and he's taken Albert to tour a submarine in Baltimore Harbor.

Not that my married life has been free of the normal ups and downs. After Al was elected to Congress, we moved from Carthage, Tennessee, to Washington, a town where many people work so hard it can put a strain on the most blissful marriages. Soon after we arrived, Kristin was born. Eighteen months later, Sarah came along. So there I was with three young children and a hardworking husband who spent three out of every four weekends

9

back in Tennessee with his constituents—a pattern he continued the whole time he was in Congress. For me, it meant having virtually no social life, since most people entertain or have dinner parties on the weekend, and I never liked going alone. Most of the time I just stayed home with the children.

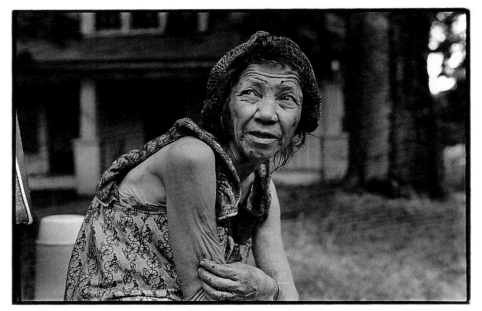

Hazel, a homeless woman in Nashville in the 1970s.

One of the ways I helped fill the void was by building a darkroom, which I did shortly after Sarah was born. I started freelancing and sold photographs to a number of publications. Volunteer work was another outlet, and I concentrated on trying to bring about more progressive policies for the mentally ill and people who are homeless. Work is good for the soul. There's no doubt about that.

I am something of a crusader at heart, and I worked hard at the causes I espoused. In Tennessee, I started a program called Tennessee Voices for Children, bringing together professionals in the field of mental health to press for more progressive policies. To cite just one example of our achievements, we advocated for a program called Home Ties, which delivers services in the home rather than in an institutional setting. Before that, Tennessee had a disproportionately high number of children with mental illness in state custody. Today, that number has been cut by two-thirds.

I've also spent a lot of time working on the issue of homelessness—an interest for which I can credit my children. One day in the early eighties, when Al was still in the Congress, I was driving the kids home after having lunch with him at the Capitol. We stopped for a light about a block away and saw a homeless woman standing on the curb, talking to herself and gesturing. Homelessness on a large scale was still fairly rare at the time, and the kids were shocked. "Mom, what's wrong with her?" they asked.

"Why is she talking to herself?" I told them she was probably mentally ill, and that she might be hearing voices. "We can't leave her here," they said. "Let's take her home with us. This is terrible." I had to tell them we couldn't take her home, but I promised them we would do something.

That evening at dinner, we talked about it with Al, and all of us became determined to help. The children began volunteering by making sandwiches for kids at Martha's Table, a local provider for homeless families. Al held hearings in Tennessee about homelessness and held a statewide conference on the problem. I put my photographer's mind to work and organized a traveling photographic exhibit called "Homeless in America," which put a human face on the numbing statistics. I wanted those pictures to move people to action in their communities. Later, I began volunteering with an organization called Health Care for the Homeless, going out with their van to provide medical care to mentally ill people living on the streets.

I am a great believer in helping those in need one-on-one. You're much more effective that way, and the satisfaction you get is so much greater when you personally give of yourself. If you never do more than write a check, if you never connect directly with the people you want to help, you will do some good, but you will never feel as fulfilled as you will if you take the time to forge a real relationship.

There were times when my crusades landed me in hot water. The one that created the most controversy was the campaign to get the record industry to warn parents about violent and obscene lyrics. It all started one day in 1985, when I listened to a song my eleven-year-old daughter had just bought and was shocked to discover how explicit the lyrics were.

Not long afterward, Susan Baker (whose husband was then Ronald Reagan's treasury secretary) and I joined forces to form the Parents Music Resource Center (PMRC). We decided to start a consumer movement to put pressure on the record industry to adopt a warning label for violence, profanity, and sexually explicit lyrics.

In spite of the fact that our goals enjoyed overwhelming public support, we were made to look like a group of sinister Puritans who wanted to trample on basic freedoms. I remember the time I accepted an invitation to represent the PMRC on a panel sponsored by the New York chapter of the National Academy of Recording Arts & Sciences. I thought it would be a chance to state our position—that we did not advocate censorship but that there *was* a problem and we did want record companies to voluntarily use warnings on labels. As it turned out, I never had a chance. Everyone on the panel except me was allied with the record industry, and they launched a series of very personal attacks. One singer said I was upset about suggestive lyrics because I couldn't handle the thought of my own children's sexuality!

It was not pleasant for us to be painted as a bunch of neurotic sex-starved housewives, although some of the things I was called were so ridiculous I had to laugh. One of my favorite lines was when I was referred to as a "high-collared prude trying to Lysol the world." Nor was it pleasant to have people whispering that I was hurting my husband politically. Al was about to run for the Democratic presidential nomination in 1988 when my first book, *Raising PG Kids in an X-rated Society*, came out, and his advisors were saying to him, "Please rein her in. This is killing your campaign." I can remember traveling in Iowa early on in the primary season and having only one or two people showing up for coffee. The organizers told me they just couldn't get anyone to attend because everyone thought I was for censorship.

Luckily, Al has never expected me to be a politically safe wife. When he first got elected, we made a pledge. We said, "Let's never do anything we really don't believe in, just because it's politically expedient. Let's only do things we believe in, even if it means losing an election." And though some people might find this hard to believe, he never once asked me to distance myself from the PMRC campaign. On the contrary, he always said, "Keep it up. You're doing the right thing. I don't care what people say."

Ultimately, our efforts produced a victory. The recording industry eventually did adopt a voluntary warning label, and I think we were able to alert parents that behind their backs commercial interests were bombarding children and teenagers with sexually explicit and violent entertainment. I know for sure that we started a national conversation on college campuses and at dinner tables across the country. And a lot of people changed their minds. Even today, people come up to me and say, "I really like what you did. It was very, very important to me."

In the course of that campaign I learned some pretty hard lessons about how easy it is to be misrepresented by the news media. Some reporters did an excellent job, but others were just plain sloppy and inaccurate. I continuously pointed out that I was not advocating censorship and that I believed strongly in the First Amendment. But my position was often misstated: one headline that went out over a newswire got it exactly backward, saying, TIPPER GORE SAYS SHE IS FOR CENSORSHIP.

I found it was difficult to get an honest hearing for a position that was complex and subtle, that wasn't black-and-white. Unfortunately, many people in our society now see almost every issue in blacks or whites, leaving little room for compromise and shades of gray. Voices that try to define a middle position often can't be heard—a trend that is truly dangerous for our country.

As the eighties progressed, I became so immersed in my volunteer work that I had the equivalent

of a full-time job. Often, I was away from home for one or two days a week. Then, one day in 1989, our son, Albert, who was six years old at the time, was badly injured, and it changed my whole life. It did the same for Al.

We had taken Albert to an Orioles game in Baltimore. As we were leaving the ballpark, he suddenly bolted away from Al and chased a friend across the street. Without warning, a car hit him, and I watched in horror as he flew through the air, scraped along the pavement, and then lay still. It was the most terrifying thing I have ever witnessed. He had so many broken bones and internal injuries that for days it was not clear whether he would survive.

Albert's accident stopped us cold. It caused both Al and me to reassess the way we allotted our time and to think about what our kids really meant to us. All of a sudden, matters that had once seemed terribly important appeared trivial compared to the life-and-death drama unfolding in our child's hospital room.

It was a very spiritual time for both of us. In Al's case, he decided to write a book and not to run for president in 1992. I cut back on my public schedule drastically; I got rid of household help and drove every car pool and cleaned every toilet. I just didn't want anybody around. The girls were older, and they pitched in around the house, which was good for them. It was good for me too. If you drive a car pool, you know that it's during those rides when the kids tell you what's really going on in school and in their lives.

Two years passed before Albert was fully recovered, and in the years since then, Al and I have remembered the lessons we learned. It's not just that we prevent ourselves from getting so busy that we neglect our children's needs. We have also realized it's a mistake to ignore our own needs. During Albert's illness, Al and I both stopped running to have more time to devote to him. My eating habits got pretty bad during that period too. I suppose it was the stress, but I just couldn't say no to ice cream and chocolate bars. Almost without realizing it, I gained twenty-five pounds. Worse, I was so out of shape that I got short of breath just trying to run around the block. Then Al took up running again, and I could see how much better he looked and felt. Finally I realized I was so busy worrying about everybody else that I was neglecting my own health.

Al encouraged me to make time for exercising. He said I would have twice as much energy for other things if I got back in shape. I joined a health club, took up running again, and did all sorts of other things like biking, rollerblading, and working out to exercise videos. During my total immersion phase, I was exercising three hours a day. Now, I put in at least an hour. I also changed my diet, cutting down on fat, drinking plenty of water and fruit juices, and eating lots of fresh food. It took me two years, but I lost the weight. More importantly, I felt better.

Since the election, I've kept up my good habits. Our menus are lower in fat, and I still try to run first

thing in the morning, after the children go to school. Running is a little different than it used to be, though, because now a Secret Service agent has to run with me. Still I know it's doing some good—one year the agent who ran with me lost sixteen pounds!

Living with the Secret Service is more than a little strange. I must confess it's taken me quite a while to get comfortable with the fact that I have to alert them ahead of time before I do anything. I can no longer say, "I think I'll go to the store," or, "I think I'll go for a run." If I'm leaving the house, I have to announce my every move in advance even though they try to be flexible.

It's tough never being able to have a private conversation with your husband in a car either. There are always two agents in the front seat, without any screen or glass between us, so Al and I usually wait to talk about things we normally would discuss in the car. If we have something intimate to share, we whisper in each other's ear.

Having spent sixteen years in public life before the 1992 election, I thought I'd be able to make a fairly smooth transition to life as the Vice President's wife. The children were also pretty accustomed to the demands of public life. But nothing really prepares you for the loss of privacy that goes with a position like this. It's not just the presence of household staff and the Secret Service agents. It's also the intense interest of the news media. Once, our family went bowling, and the *New York Times* printed each of our scores the next morning. We haven't been able to get the kids to go bowling with us since then.

This kind of scrutiny is hard enough on adults, but it's particularly unfair to children. They don't know the background. All they know is that the limelight can be very harsh, and they don't like it. So I have fought hard to give our children some privacy and make life here at the "official residence" feel as normal as possible.

We created a family zone on the second floor that is almost like a small apartment. There's a large family room where we eat our meals and hang out and where the children do their homework. Next to the family room is a kitchenette we had installed so the kids could fix their own snacks or meals. This way, we can stick to as many of our old family routines as possible. Every morning, Al wakes up the children one by one. It's something he's always done, and he likes doing it. And we always eat breakfast together. I make everyone bagels, grits, oatmeal, whatever they want, although it's usually pretty simple fare, and we talk and read the newspapers.

Al and I still faithfully attend the children's athletic events. No matter what's going on in the government, one of us—and sometimes both of us—is on the sidelines. It's a little different now, with Karenna and Kristin away this year. But the younger ones' activities keep us busy enough. Sarah plays on

the soccer and lacrosse teams, and Albert plays basketball on a club team and plays soccer and lacrosse for his school. We do a lot of other things as a family too, like going skiing or going to a movie together on the weekends, which has always been one of our greatest pleasures.

As hard as we've tried to make life normal and get rid of any pretentious trappings that go with Al's job, some things can't be changed, such as the armed guards that surround our house. Don't get me wrong. I not only understand why they have to be there, I appreciate all of them for how hard they work. But it's only human nature for the children to dislike whatever sets them apart from their friends. I'll never forget the look on my sixteen-year-old's face when we first moved in and she discovered that her friends had to go through White House operators to get her on the phone. "Mother," she said, "you've got to do something about this." And I did. We got two personal phone lines installed so their friends could call directly, which had never been done before.

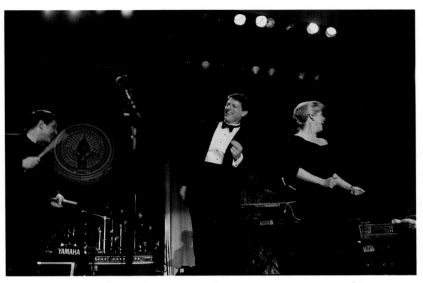

On stage with Paul Simon at the Tennessee Inaugural Party.

We've also succeeded in getting the Secret Service to do away with limousines for the most part. When we go out as a family, we ride in a normal family car or a minivan. When the agents go out with the kids, they dress casually—even in jeans. I've asked the agents to wear casual clothing when I'm out and about doing errands too.

When somebody recognizes me in a store, the first thing he or she usually asks is, "Where's the Secret Service?" They're around, but people seldom notice them.

The Clintons have it much rougher in this respect. When the President or Hillary leaves the White House grounds, there is almost no place they can go without causing a huge fuss, which makes them have to think twice about doing some things. Reporters follow them everywhere, so even the simplest excursion can end up in the next day's newspaper. Being the President or the First Lady now requires a sacrifice that redefines the concept of public service.

. . .

15

Getting to know the Clintons has been one of the real bonuses of being involved in the administration. I don't think they are very well understood by the public, partly because all three of them are such private people. They're obviously a very close family. I see evidence of that all the time. When I'm upstairs in the family quarters of the White House with them, or when we're in a private room before public events, or when it's just the two families spending time together, the President is very affectionate with both Hillary and Chelsea, as they are with him.

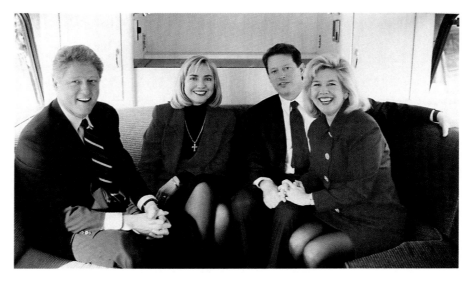

On our tour bus just prior to the inauguration (photo by Sarah Gore).

The four of us do a fair amount of socializing together outside of the official events that bring us together. We've had the Clintons over to dinner, and they often include us in small private dinners at the White House. They don't have to invite us to spend an evening with them and their guests, but they do it because we're good friends and they know we'll enjoy it.

The President and I happen to have the same birthday—August 19—which the families sometimes celebrate together. When we were on the campaign trail in 1992, the four of us, with our children, spent the day building a house for Habitat for Humanity in Atlanta. Another year, our families got together for a barbecue by the pool at the White House.

Al and Hillary both say the President and I are alike in some ways—maybe it's partly because we share the same birthdays. We're both gregarious. We both get energized from being around people, and we seem to have a similar sense of humor. At least, he always laughs at *my* jokes. Hillary in particular will joke to Al, "Oh, we're the serious, stiff ones, stuck over here in a corner, while the two of them are out there making everybody laugh."

Hillary and I got to be very close during the campaign. We're different people, of course, but we have a lot in common. We're roughly the same age, we're both mothers, and we both have deep, long-held concerns about the less fortunate and about

children. On top of that, we've shared an experience that is virtually unique, being married to a President or a Vice President. Sometimes I feel as if no one but Hillary can really understand what I'm going through, and she has said it's the same for her.

Early on, the four of us made a pact that we would not let other people cause trouble between us or make us jealous of each other. We pledged that if anything troublesome came up, like reading a hurtful story in the newspaper, we'd immediately get on the telephone and find out what really happened so we could straighten it out right away. Happily, our relationships are so solid that nobody has ever had to make that phone call.

I'm often asked how I spend my time these days, and the first thing I say is that I'm lucky because no two days are alike. One day, I might make appearances in three different states. Another I might be scheduled to visit schools, homeless shelters, or work sites for mentally ill people. Often, I am called on to perform official duties, like accompanying Al on trips abroad. We do a fair amount of official entertaining, and the Clintons have always graciously included us in state functions. As a card-carrying member of this administration, I also try to do my part for the Democratic ticket. I give a lot of speeches at the request of the Democratic National Committee, and I chair the Women's Leadership Forum (WLF), a Democratic group that encourages women to take part in the political process. That translates to many meetings and receptions and traveling to states on behalf of the WLF.

Many of my speeches are related to my role as the Advisor to the President on Mental Health. This position came about as a result of all the time I spent with the Clintons on the bus during the 1992 presidential campaign, when the President discovered how passionate I am on the subject of mental health. One of the points I try to get across when I speak about mental illness is that treatment actually works. If someone has a broken bone, no one questions that with proper treatment it will eventually heal. But people have not yet realized how much progress has been made in managing and curing mental illness. The data show high levels of success in treating everything from substance abuse to chronic depression to schizophrenia. For one thing, new pharmaceutical breakthroughs have made a big difference. When doctors use a combination of medication and therapy, the cure rate for schizophrenia is now over 60 percent. For depression it's 80 percent! If statistics such as these were widely known, the insurance industry would no longer have any excuse for refusing to pay psychiatric bills for people who are suicidal or so depressed they can't work or take care of their children.

My interest in the field of mental health goes back to my own childhood, when my mother suffered

from serious bouts of depression. This was bad enough, but the situation was made worse by her fears that someone would find out, because at that time the stigma associated with mental illness was so enormous. Once, when my mother was in the hospital for something else, I wanted to tell the doctors about the medication she was taking. But she was so terribly fearful of anyone finding out—even a doctor—that she wouldn't let me tell them. It broke my heart. For decades, she suffered in silence; only in the past year or so has she been willing to speak openly about her experience.

As the President's advisor on mental health issues, I am working hard to destigmatize mental illness. One of the things I'm proudest of is having prodded the government to change the way it handles the subject of mental illness in the hiring process. Among other things, applicants no longer have to disclose whether they've had family or marriage counseling. Furthermore, the question "Have you ever seen a psychiatrist?" is no longer placed next to the one asking "Have you ever committed a felony?" In addition, information not relevant to the hiring process remains confidential. The brain, after all, is a part of the body. Why should we discriminate against a disorder that emanates from the brain? Why should mental illness be put in a completely different category from a disease of the lung, the liver, or the heart?

. . .

Not long ago, someone asked me what I wanted to be remembered for. I said I wanted to be remembered as a wife, a mother, and an advocate for mental health and the homeless. I also want to be remembered as someone who enjoyed life. This may sound frivolous, but just about everybody needs to take more time to have fun. People work too hard, and they take themselves too seriously. They should go rollerblading once in a while, like I do. As the kids say: Get a life!

Washington is particularly rough on people in politics, which in recent years has become increasingly vicious. For too many people, the rules of engagement today are simple but brutal: take no prisoners. The combatants want to win at any cost, so they wind up calling each other names instead of arguing the issues on their merits. I want to help bring back civility and a sense of fun, and I deliberately try to lighten the atmosphere around me. I think it's extremely important to remember that there is so much joy in life. Al and I have often said that we need to work hard, but we need to celebrate each other too.

When I take pictures, I try to find the joy and the humor in different situations, and I've found plenty of both since Al was elected Vice President. I've also seen things that moved me deeply, like the people who lost everything they owned in the Midwest floods, or the sick and starving children in Rwanda.

It's been very gratifying to be able to capture these realities. I think back to Al's first congressional campaign and how I was unable to step back far enough from what I was doing to take pictures. By now, I've taken part in so many campaigns and public situations that I am comfortable slipping back and forth between the role of participant and the role of observer. I can't tell you what a thrill it was when the pictures I took during the 1992 campaign were exhibited in Washington by the National Museum of American Art, the Woodrow Wilson House, and now the Democratic National Committee.

Sometimes it can be delicate to take a photograph of a stranger, and when I first started taking pictures during the campaign, I wondered how the subjects would react. To my delight, I discovered it nearly always created an instant bond between us. People feel complimented to be singled out, whether they are a head of state or a face in the crowd. Perhaps they sense that I'm not trying to invade their privacy, that my goal is to capture their essence and their humanity. If I succeed in doing that with the photos in this book, I'll feel I have accomplished a lot.

A child in Salido, Texas, during the 1992 campaign.

An American Reunion

Three days before the inauguration of William Jefferson Clinton as the forty-second President of the United States, the Clintons and the Gores set off by bus from Monticello, the home of Thomas Jefferson, retracing the route Jefferson took by horse-drawn carriage in 1801 on the way to his inauguration. The week of festivities culminating in the 1993 inauguration was called an American Reunion. For the four of us, being together on the bus again was also a kind of reunion, recalling the days and weeks we spent campaigning together in 1992. We laughed and joked just as we had in the past. At the same time, it was sobering to think about what lay ahead. We all talked about the immense responsibilities that the President in particular was about to assume, and I know that he and Hillary were deeply affected by the prospect.

It was exhilarating to travel through those small towns in Virginia. Thousands of people lined the route, waving flags and cheering wildly, and a feeling of hope and patriotic fervor was palpable all along the way. That night, we reached the Potomac River and crossed Memorial Bridge into Washington on foot, and so many people converged on us that I found it hard to hold on to the younger children's hands. The force of the crowd, surging forward to see us and touch us, was like a tidal wave advancing.

I remember a moment during the walk into Washington when Hillary and I exchanged one of those looks that don't require words. "This is a breathtaking, historic moment," we were saying silently to each other. "This is our chance. Let's seize it, but let's never forget the trust that has been placed in us."

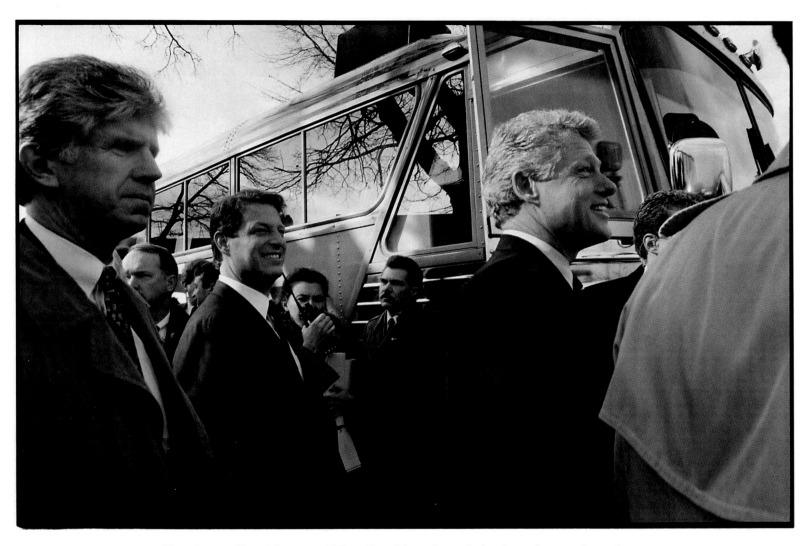

The future President and Vice President board the bus that took us from
Monticello to Washington. They were exhausted from the campaign and
faced a week of intense inaugural activities. But the crowds that greeted
us all along the route energized them enormously.

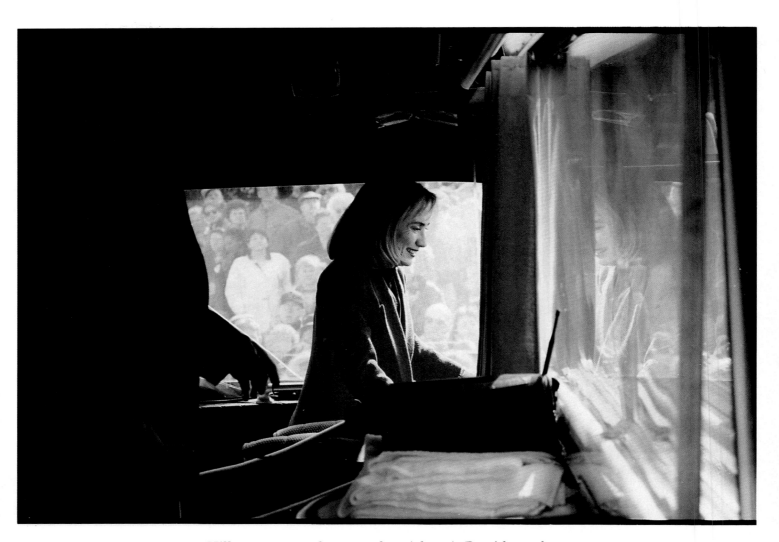

Hillary emerges from our bus (above). President-elect
Clinton addresses the citizens who came to wish us well
in Culpeper, Virginia, one of the stops on the route
from Monticello to Washington.

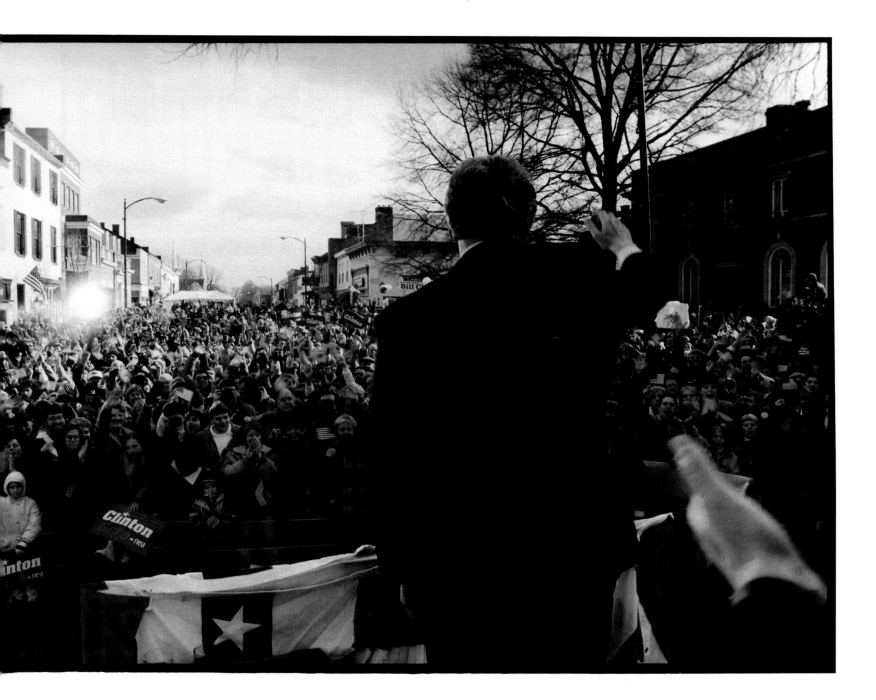

Inaugural morning. In order to work off a little of our nervous energy, Al and I jogged the seven miles from our house to the Capitol (that's why Al is in jogging clothes). Soon after we arrived, Al practiced the oath of office with Senator Wendell Ford of Kentucky, then chairman of the Joint Congressional Committee on Inaugural Ceremonies, who earlier had rehearsed the President-elect. Meanwhile (opposite), workmen prepared the Capitol grounds for the huge crowds that would assemble later.

House and Home

We didn't move into the Vice President's Residence for six months because it had to undergo substantial repairs. But none of us minded: We loved our house in Arlington, Virginia. The day we finally moved, we all felt a little wistful. It was particularly hard for me, leaving the place where I'd lived for most of my life. My immigrant grandfather built the house—an English Tudor—in 1938, when my mother was still a girl. I lived there from the time I was four until I went away to college. After Al was elected to Congress, we moved back to Washington, and my grandmother sold the house to us.

During the six months it took to refurbish the official Residence, the Secret Service was a constant presence around the Arlington house. We thought the neighbors might object to all the hubbub, but it was just the opposite. They felt safer with so much security around. The agents blended in so well they got invited to neighborhood parties.

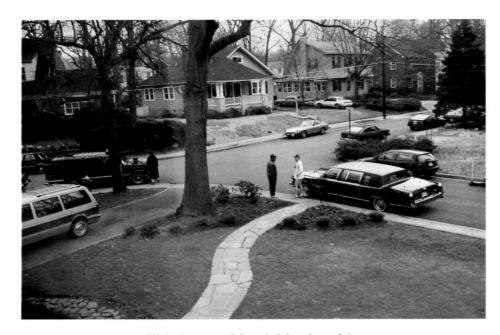

This is our old neighborhood in
Arlington, Virginia, and that's Al and his
lead secret service agent after a jog.
Albert (right) takes a last look out his
bedroom window on moving day.

The Vice President's Residence is an amazing place. I love living in it, and who wouldn't? A stately white brick Victorian, it has wraparound porches and is set on twelve acres of rolling lawns and gardens. The house was built in 1893 by the navy (which still owns the property) for the superintendent of the United States Naval Observatory. The navy still operates a major observatory here with five telescopes, an atomic clock, and more than four hundred employees. The navy also supplies the personnel to take care of the Residence and grounds. The house itself is not as large as it looks. There are five bedrooms, which is perfect for a family with four children, like ours, although that doesn't leave any space for a guest room. And, it's a great place to entertain, which is good, because we have a lot of official visitors.

The government did not provide a place for Vice Presidents to live until 1974, when Congress designated this as the "first official temporary residence of the Vice President of the United States." It was unfurnished when the navy turned it over to Nelson Rockefeller, Gerald Ford's Vice President. The Rockefellers decorated it and used it for entertaining, but they never lived here. They did leave some furniture, though, including a massive mahogany dining-room table and a set of Williamsburg-style chairs.

Walter Mondale, Jimmy Carter's Vice President, and his family were the first to take up residence. The Bushes and the Quayles lived here too. All of them did an excellent job of beginning to furnish the house; we just filled in some of the blanks. Some of the pieces we borrowed from the State Department,

Sarah perched on the banister the day we moved in.

which has a fine collection of early American furniture. The art on the walls is on loan from the National Museum of American Art, the Phillips Collection, and the National Gallery of Art. We also moved some of our own furniture in, like our breakfast-room table. We did it partly out of necessity and partly because we felt more comfortable having some of our old familiar pieces around. In addition, we've also purchased some things the house needed, like a stereo cabinet for the family room, which will stay here after we've gone.

Probably because the house has not been used as a vice presidential residence for very long, we discovered that there were no set procedures for furnishing it or taking care of it. For example, there is no comprehensive inventory. As a result, objects that belonged here had a way of getting lost. In most cases, they were in storage, but there was no way to track them down. It was only by accident that we found Joan Mondale's wonderful pottery collection and some of the other works donated to the house by American craftsmen when the Mondales lived here. (We discovered them in a garage on the grounds, packed in unlabeled boxes.) As a result, I have started a project to catalog everything in the house that is meant to stay here. Volunteers are in the process of inventorying every item from Christmas decorations to teacups to sofas and chairs.

I have also been working with the navy on the care of the grounds. When a tree needs to come

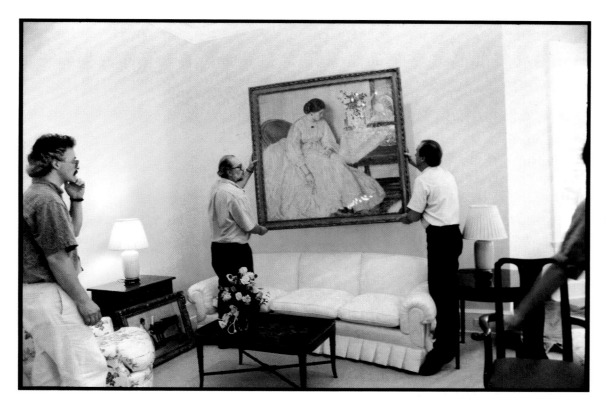

Moving in. The museum staff hang one of my
favorite paintings, a portrait by the artist Frederick
Carl Frieseke. It was loaned to us by the National
Gallery of Art.

Secret Service dogs sniff for bombs.

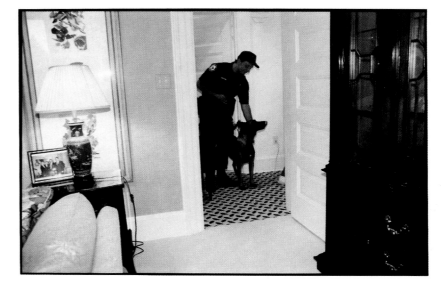

down, I talk to the gardeners, Mike and Beth, about what should be planted in its place. A couple of years ago, we brought in horticultural experts who discovered a tiny remnant of an old-growth forest in the backyard, so we are trying to bring back the native trees and plants by transplanting identical specimens that have survived elsewhere. We've also put in some new gardens and added plants to the delightful wildflower garden. We did it with private money raised by the Vice President's Foundation, which is charged with enhancing the historical significance of the Residence. We want to be good stewards of these grounds and of this house as long as they are entrusted to us.

While on a run along the historic C&O Canal, I took this picture of a Secret Service agent and Shiloh, one of our three dogs. It's taken a while to get used to having other people around all the time—in fact, I'm *still* not completely used to it.

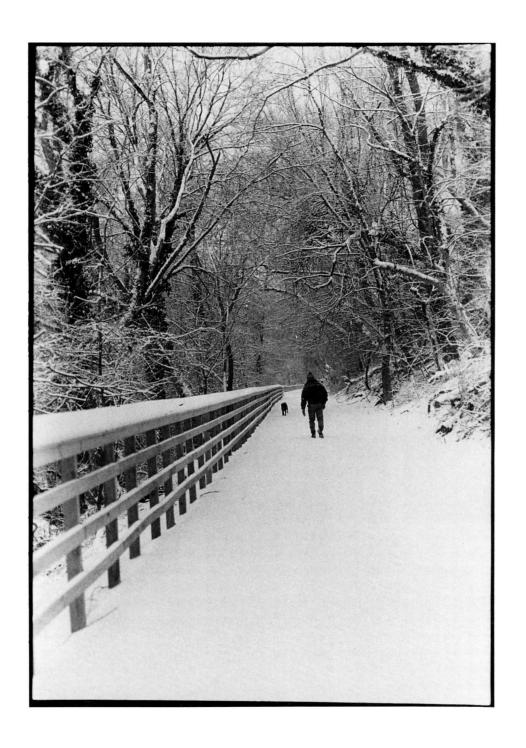

 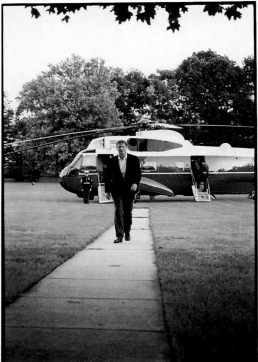

Hi, honey, I'm home! Al arriving at the Residence after an
out-of-town trip. I got to thinking one day about how the
extraordinary gets to seem so ordinary after a while, so I
decided to meet him on the lawn with my camera.

Behind the Scenes

When I think about the scenes I've been privileged to photograph since my husband and Bill Clinton were elected in 1992, I can hardly believe my good luck. Watching Al's advisors bite their nails before he and Ross Perot debated the NAFTA treaty on CNN, waiting in the Oval Office for the result of the Congressional vote on the President's first budget— now that's what I call a front row seat to history. Of course I don't have my camera with me all the time, and it's a good thing I don't! There are moments I want to experience to the fullest without the distraction of thinking about how I'm going to frame the shot. At times, I get so carried away shooting, Al has said, "Stop. Put that camera down. Enjoy the moment." He's right, of course, but as I once told him, "Just think of the scrapbook we're going to bequeath to our children one day!"

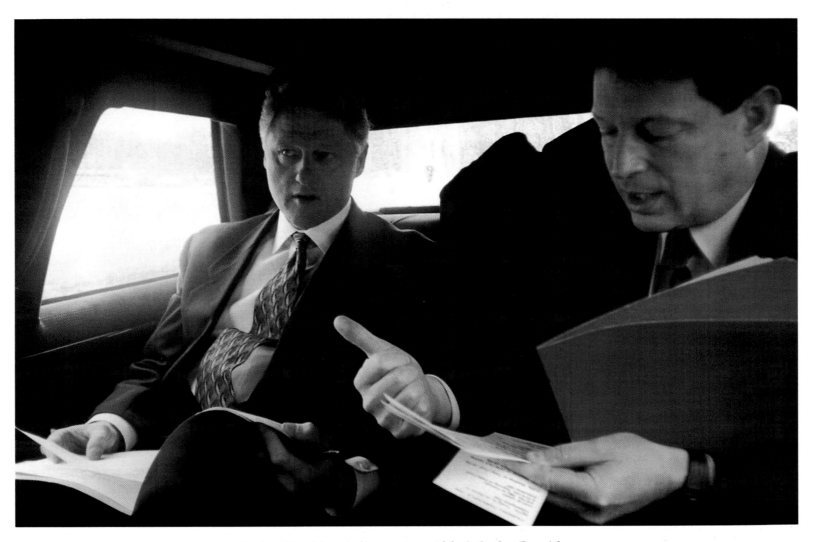

In the President's limousine. Al briefs the President
before the signing ceremony for the Telecommunications
Reform Bill in February 1996.

OPPOSITE: The President and Al conferring before the news conference in March 1993 to announce the National Performance Review, Al's plan to "reinvent government," popularly known as REGO. I like this picture because I think it captures the easy working relationship they have. I also like the coffee cup—you see the President cradling a cup quite often.

Among those gathered for the REGO announcement were, from left to right: the late Les Aspin, then secretary of defense; Secretary of State Warren Christopher; our brother-in-law, Frank Hunger, head of the Civil Division of the Justice Department; Albert Gore Sr.; and Lloyd Bentsen, then secretary of the treasury.

The President and Al, with forklifts of paper signifying the waste and duplication REGO aimed to eliminate. And it has! Nearly $100 billion of wasteful spending has already been cut, as government has been "downsized" more than ever before in history. With two hundred seventy-three thousand unnecessary positions eliminated from the bureaucracy, thousands of unneeded offices closed, hundreds of programs ended, and many thousands of pages of regulations no longer needed, our government is finally beginning to work better and cost less. And it is now smaller than it has been since the 1960s.

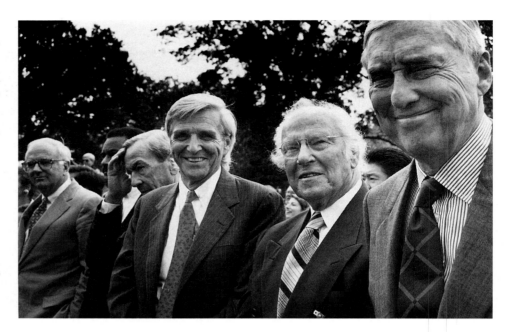

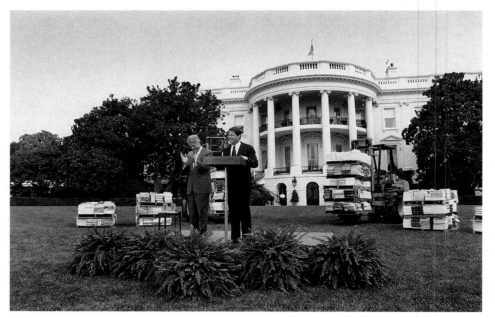

40

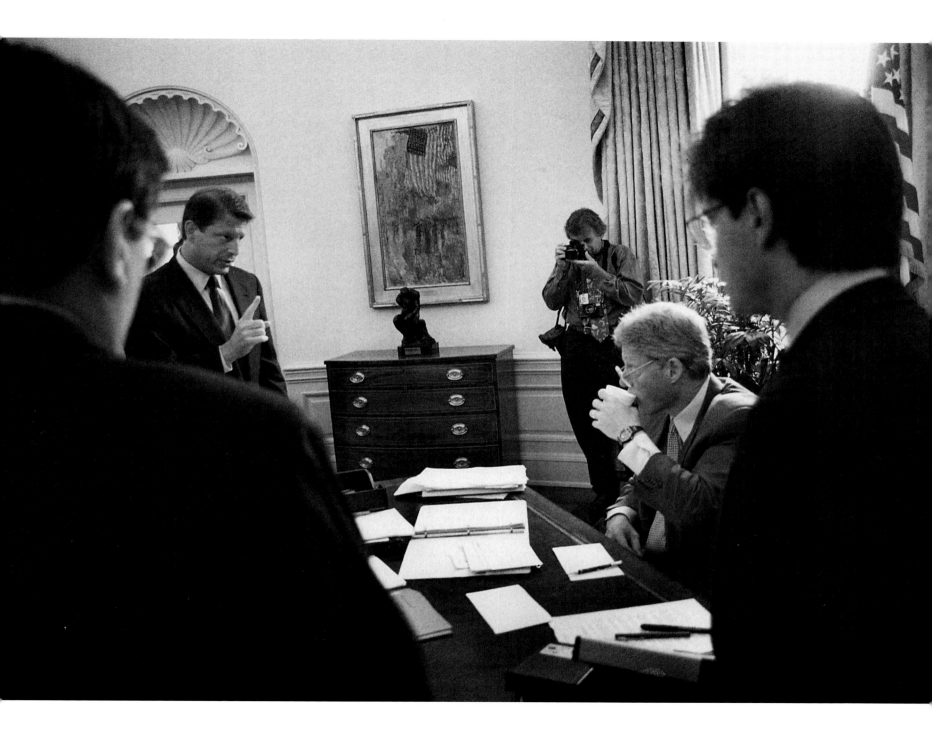

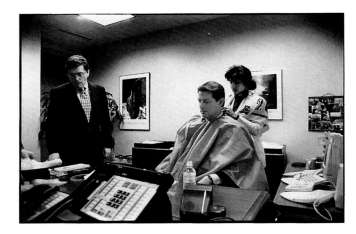

Al, concentrating before the NAFTA debate in 1993 with Ross Perot on *Larry King Live*.

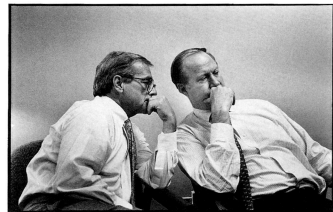

Close advisors Bob Squier (left) and David Gergen still look worried as the debate begins.

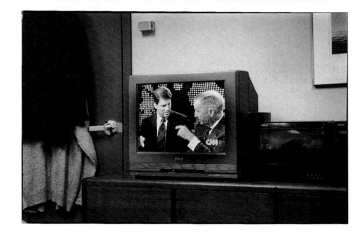

Everybody agreed the debate was a big victory for Al, but initially nobody except Al and President Clinton thought it should even take place.

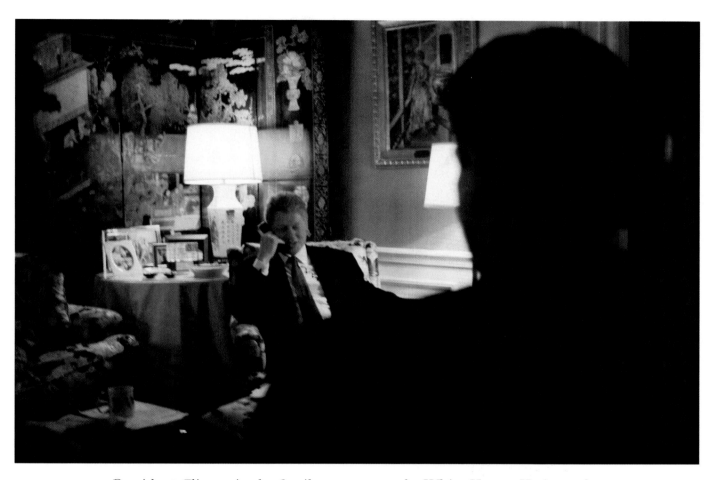

President Clinton in the family quarters at the White House. He is on the phone with the president of Mexico after the passage of the North American Free Trade Agreement (NAFTA) by the Senate. That's Al in the foreground; he had just returned to the White House after presiding over the vote.

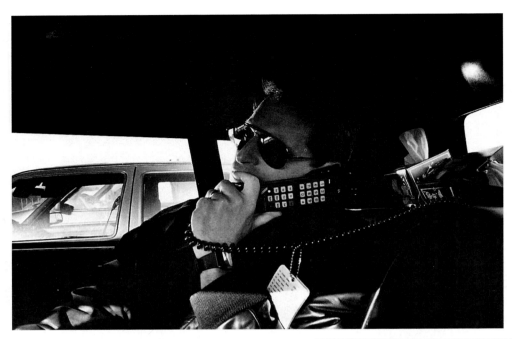

You can run but you can't hide. Al is in constant contact with the White House, or is always available by phone. At right, he's having a two-fisted conversation with former President Jimmy Carter in North Korea on one line and National Security Advisor Tony Lake at the White House on the other, discussing the Koreans' threat to go ahead with their nuclear program.

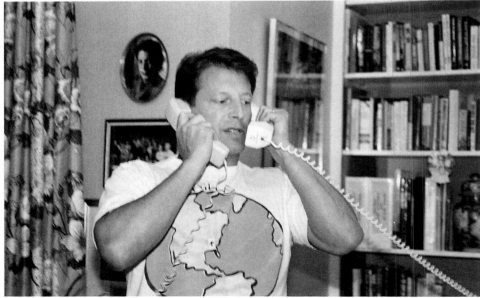

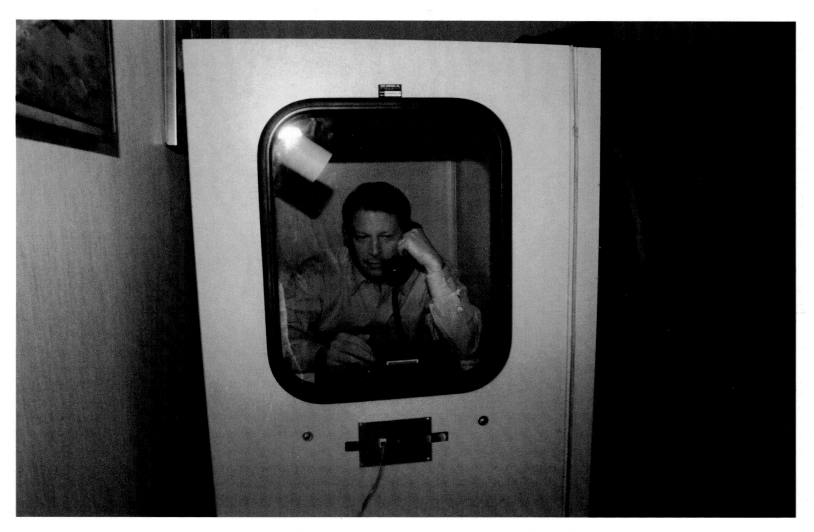

Al on a secure phone in our hotel room during a trip to Moscow.
The booth is soundproof and "bug"-proof.

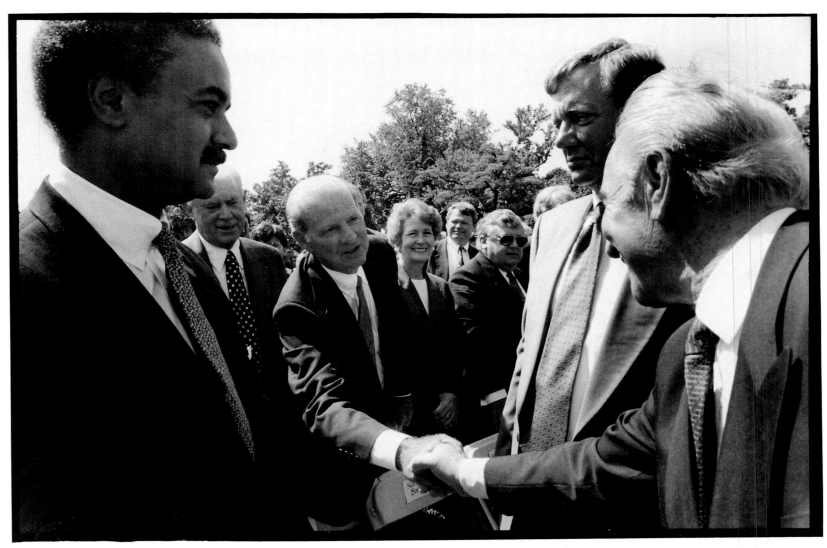

Middle East peace comes to the White House lawn. The first peace treaty was signed by Yitzak Rabin and Yasir Arafat on July 7, 1994. Here, James Baker, secretary of state under George Bush, and Shimon Peres, then foreign minister of Israel, shake hands. Also attending were the late Ron Brown, then secretary of commerce (on the left); Cyrus Vance, President Carter's secretary of state (behind Jim Baker); and several other people from previous administrations who were also invited in recognition of their contribution to the peace process.

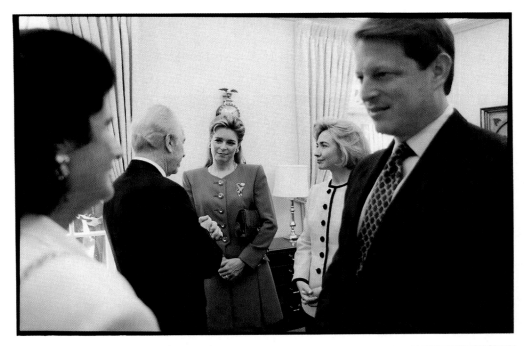

In the Oval Office, before the signing of the treaty. From left to right, Lea Rabin, Shimon Peres, Queen Noor, Hillary Clinton, and Al. I have gotten to know these women fairly well, and they are all strong, accomplished individuals who are as committed to peace as their husbands. Queen Noor—an interesting, articulate woman—and King Hussein and their four children have come to lunch at our house. The King and Queen are a close, affectionate couple.

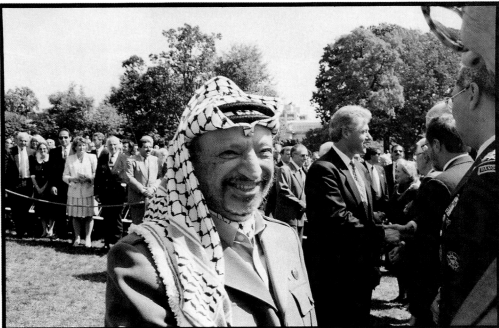

President Clinton with Yasir Arafat on the White House lawn. The Palestinian leader is very reserved and cautious, but underneath you sense his eagerness to make friends.

Upstairs in the White House, before the ceremony. From left to right, Hillary Clinton, Queen Noor, Suzanne Mubarak, Lea Rabin, and Suha Arafat.

Little did we know that a few weeks later Mrs. Rabin would be a widow. Yitzhak Rabin's death hit us all very hard. For the President and the First Lady as well as for Al and me, it was like looking around in battle and seeing your comrade fall. When Yitzhak Rabin was bearing the standard for peace in Israel, the loudest voices were those of the extremists who opposed him. At times, Lea once told me, it made her feel very isolated and alone. I admire her enormously. She has always shown so much leadership and courage. Especially now.

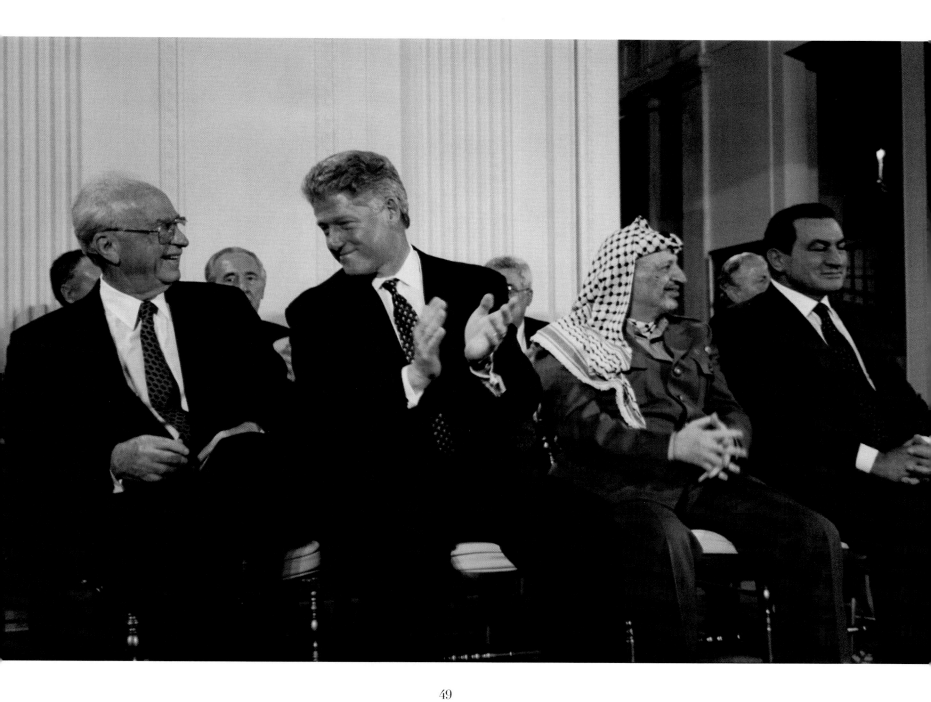

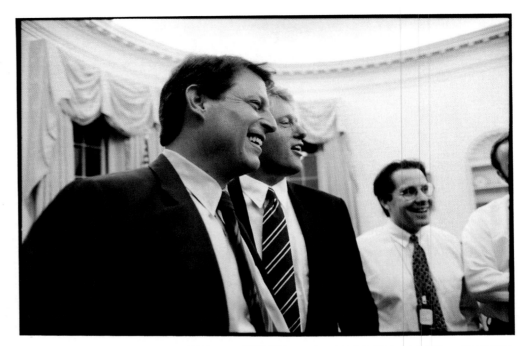

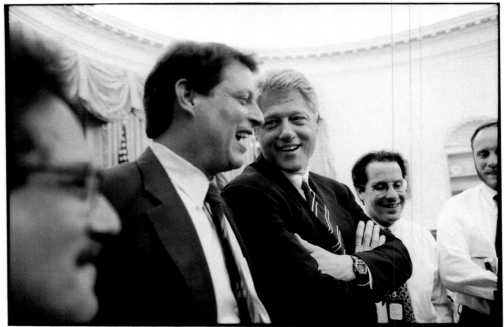

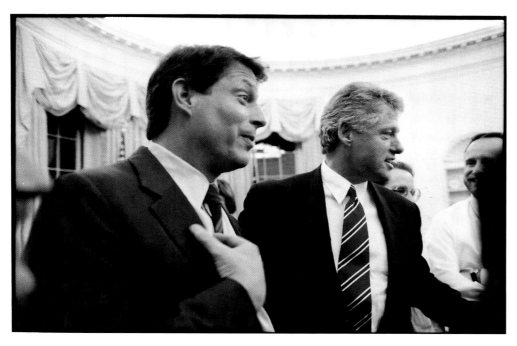

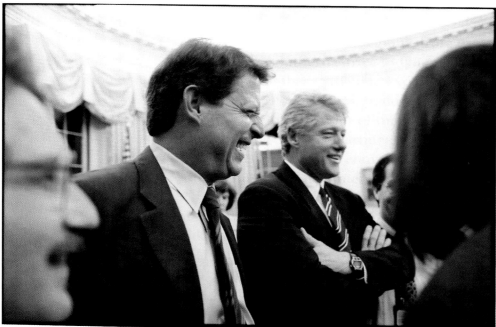

In the Oval Office on August 6, 1993, the night Al broke the tie in the Senate and ensured a victory for President Clinton's first budget. Everyone was extremely tense that night, wondering if the budget bill would pass. Afterward, we all gathered in the Oval Office to celebrate.

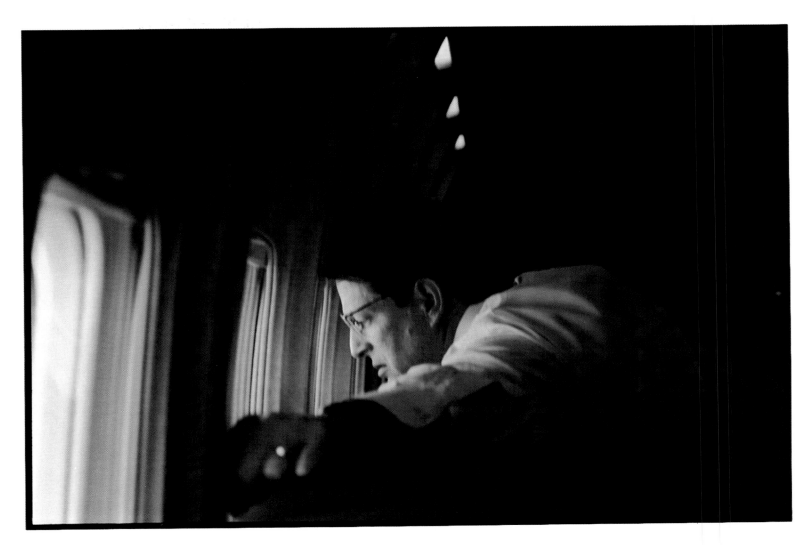

Al headed the delegation sent to Mexico for the inauguration of
President Ernesto Zedillo on November 30, 1994. Here he is looking
out of the window of *Air Force II* during the flight to Mexico.

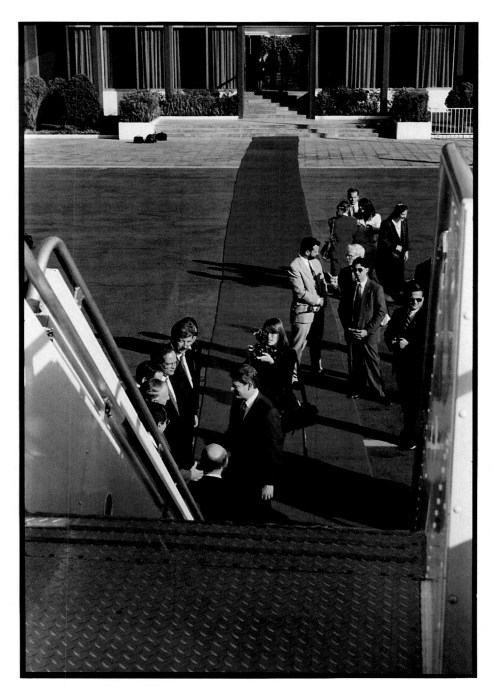

We get the red carpet treatment
in Mexico City.

On top of the Pyramid of the Sun,
Teotihuacán, Mexico. The pyramid
is the largest known ancient
structure in the Americas, almost as
big as the Great Pyramid of Giza in
Egypt. Teotihuacán was the center
of a once-great civilization that
flourished from A.D. 100 to 750.

At the inauguration of Nelson
Mandela, May 10, 1994. After
introducing Hillary Clinton to
Winnie Mandela, Jesse Jackson
is gesturing to me to come forward.
It was one of those instances
when my desire to shoot pictures
almost got in the way of being
a participant.

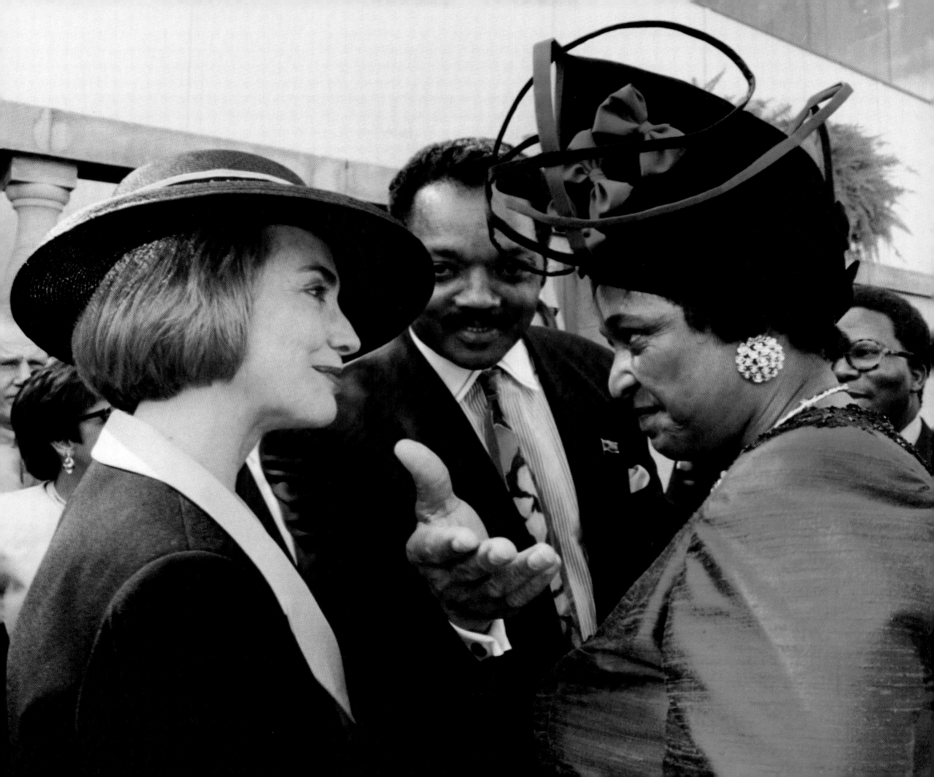

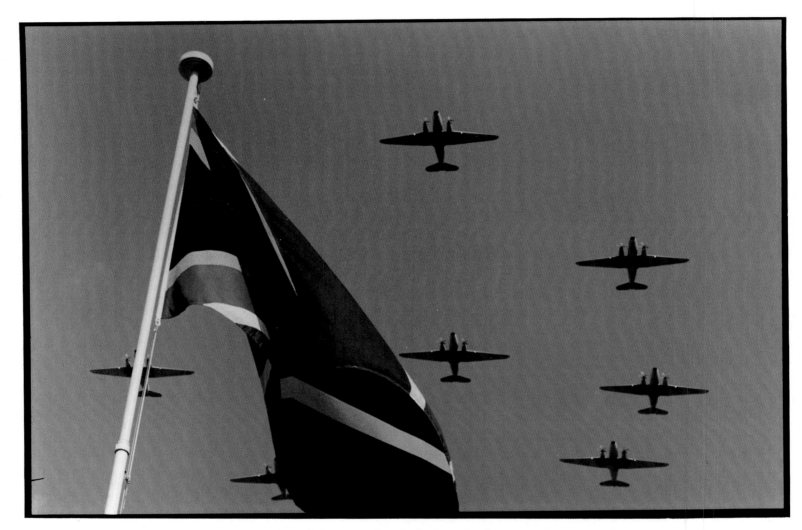

South African jets flying overhead during the inaugural ceremonies.

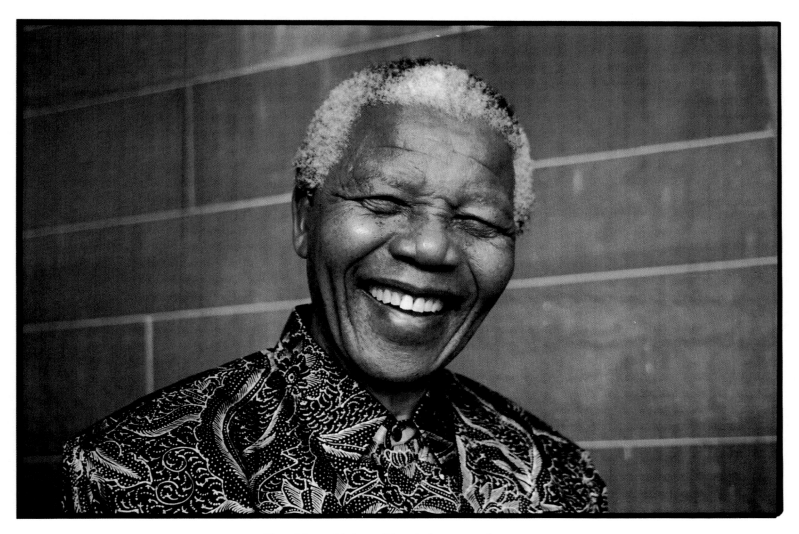

President Nelson Mandela poses for me.

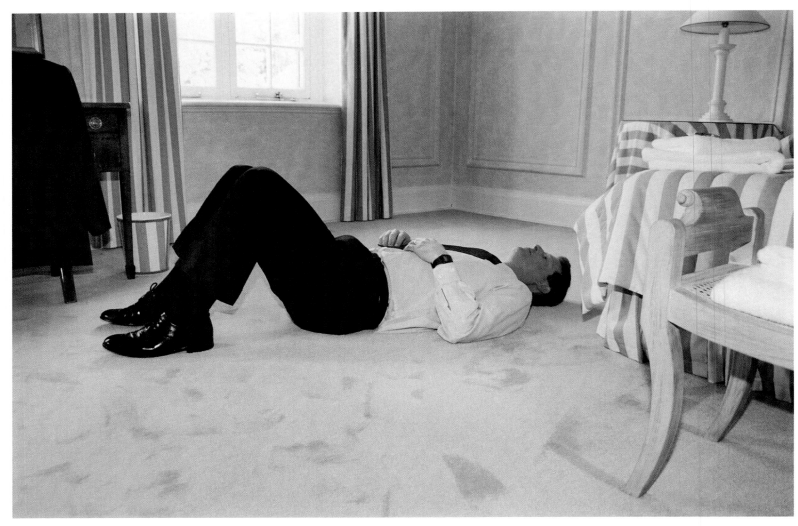

While in South Africa, Al tries out some exercises for a sore back
at the suggestion of Hillary Clinton.

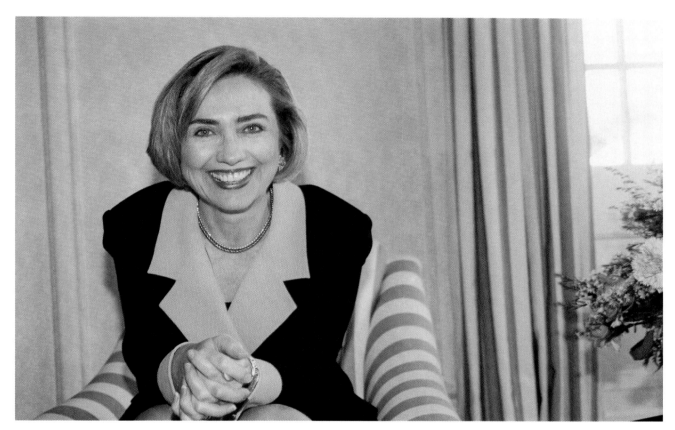

I took this picture of Mrs. Clinton while we sat together in
a holding room in the presidential palace in Pretoria, waiting
for the security arrangements to be checked out. You really
get to know people waiting around in "holds."

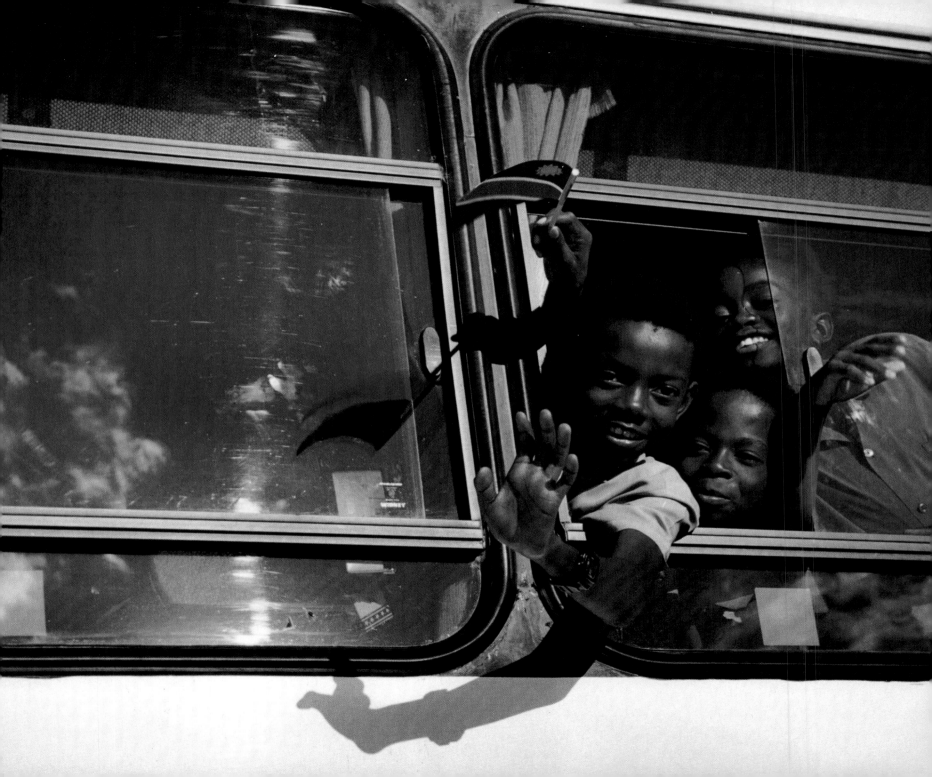

Schoolchildren on a bus in Namibia.

En route to the Middle East in March 1995. A natural-born teacher, Al is using sheets of paper, each representing one hundred years, to show Albert how old Egypt's pyramids are. When I took these pictures, I remember thinking, "This is *so Al*." By the time he was finished, he had created a time line equal to the length of the plane.

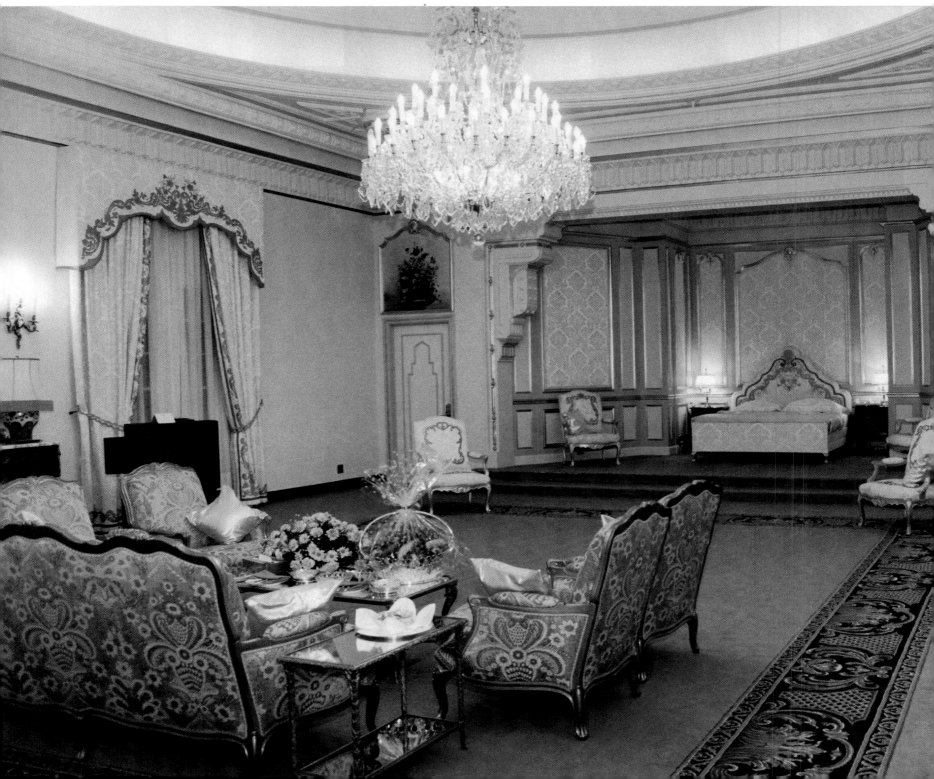

Our bedroom in the
"guest palace" in Riyadh,
Saudi Arabia.

71

A little girl on the street in Cairo.

OPPOSITE: An Egyptian security guard on a camel. I was on horseback, which is a romantic way to see the pyramids. Not too many years ago, you had to drive for more than an hour through the desert to see them. Now, Cairo has spread out so much that they are just on the outskirts of town.

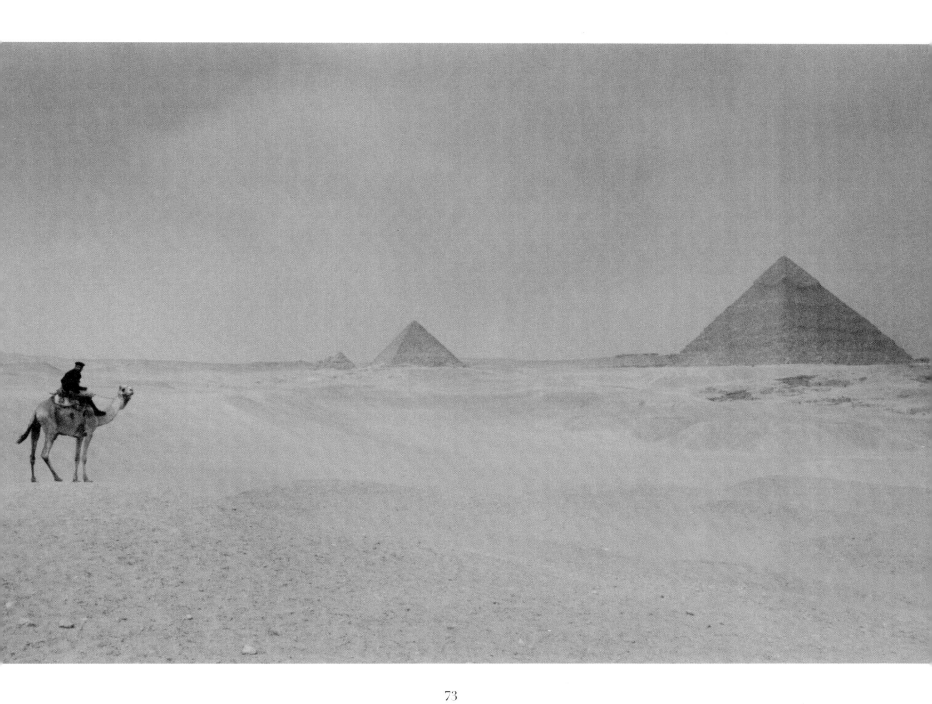

Labors of Love

The wife of the Vice President is expected to take up a cause or engage in what used to be called "good works," but this was something I have never had to worry about. I simply chose to continue working on the issues I was already concerned with, namely, mental health programs, homelessness, and advocacy for children.

One of the things I've enjoyed most was starting a photo exchange program for children. When I visit schools, I have the students take pictures of themselves and their cities and exchange them with children in foreign countries. Whenever I'm traveling, I try to bring new youngsters into the program. I'll visit a classroom and talk about photography. Then, if possible, I'll go out with the students to take pictures, and I'll help them set up an exchange with children in a different country.

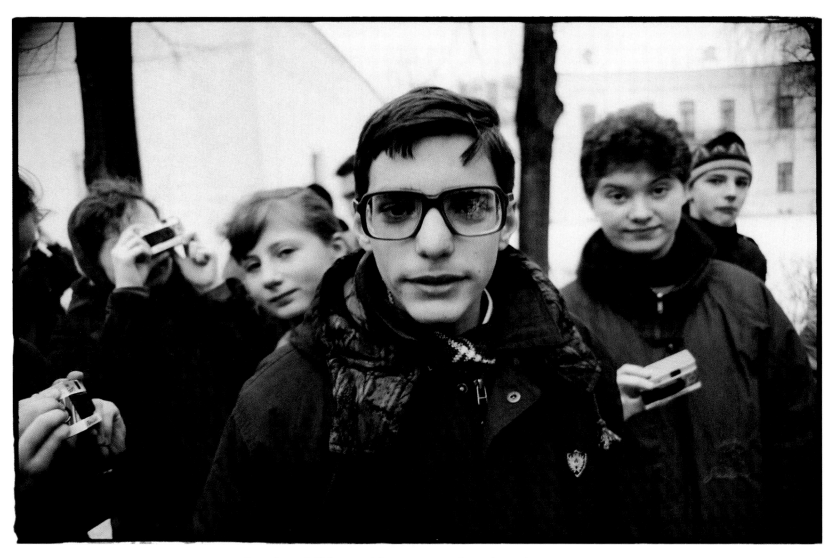

Russian children with cameras, shooting pictures to
exchange with kids in the United States.

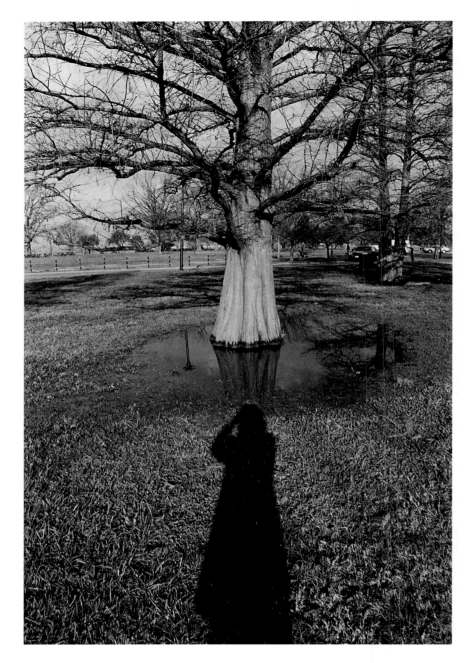

Self-portrait at Washington's
Haines Point, taken during a photo
exchange project.

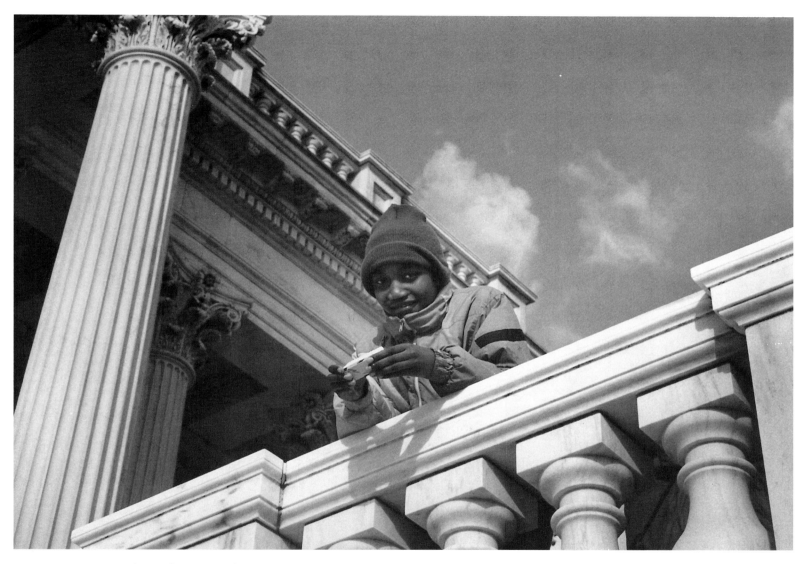

A student at Jefferson Junior High School in Washington. She and her classmates
introduced me to some of their favorite spots in town and took pictures
to exchange with schoolchildren in Argentina.

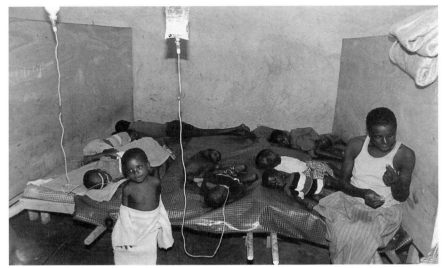

Sick and dying children in the orphanage in Goma, Zaire.

The civil war in Rwanda, where some five hundred thousand people were killed and more than a million displaced, produced a tragedy of almost unfathomable proportions. I decided to go there in August 1994 to show the victims that the people of America cared about them. I also went to thank the U.S. military and the relief organizations who had mounted a massive operation. The troops were creating an infrastructure—essentially a lifeline to make it possible to bring in clean water, medical supplies, and food. Organizations like the Red Cross and Doctors Without Borders were administering the aid.

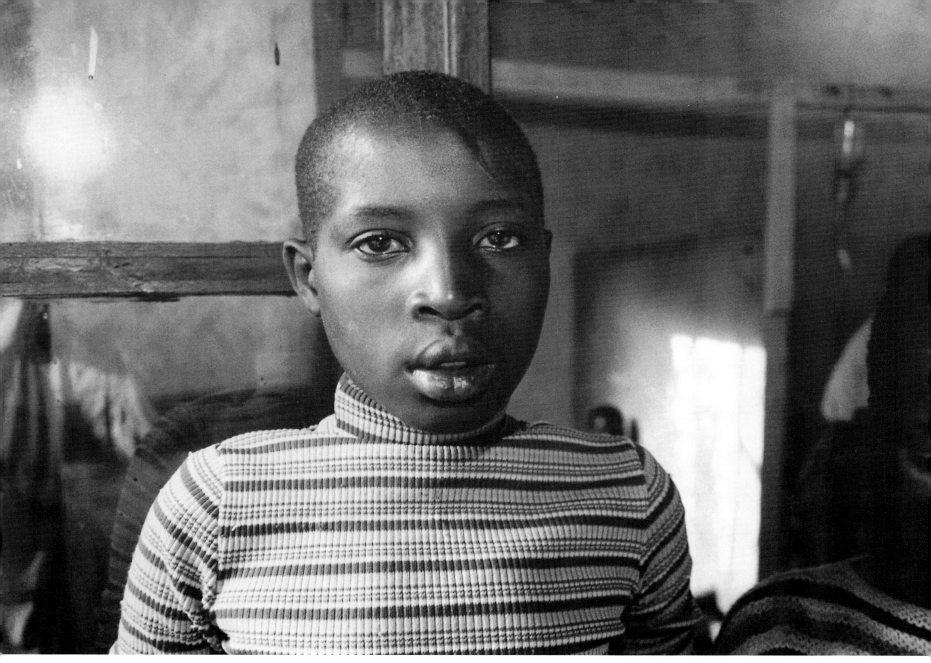

A machete blow to the head was not fatal to this twelve-year-old girl,
but she told me she had seen her mother, father, and brothers
hacked to death in front of her eyes.

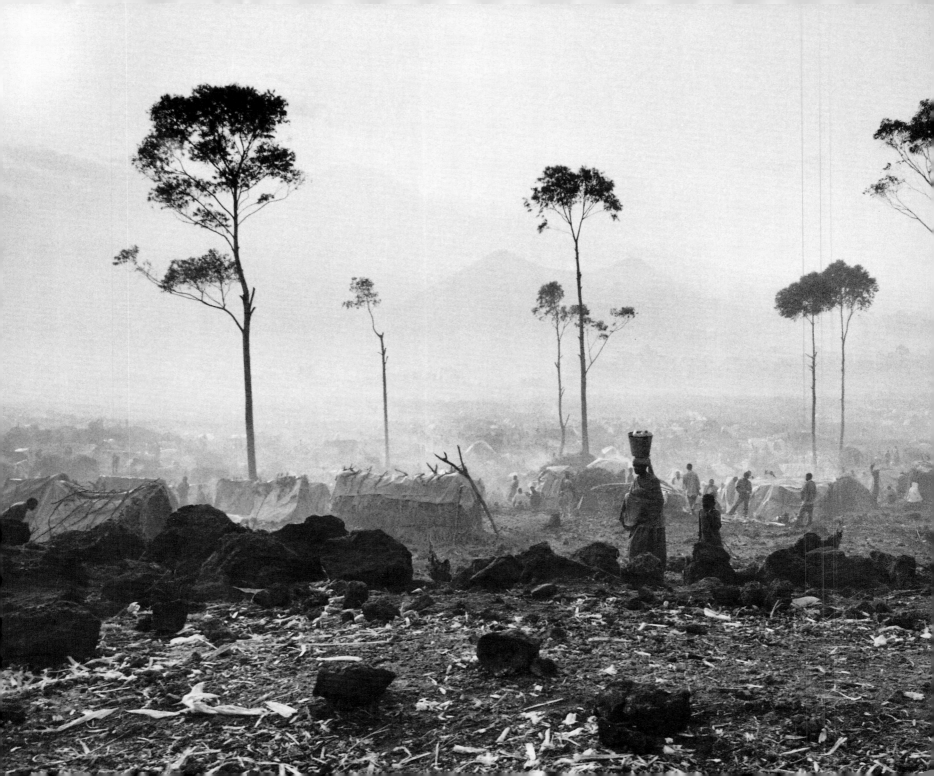

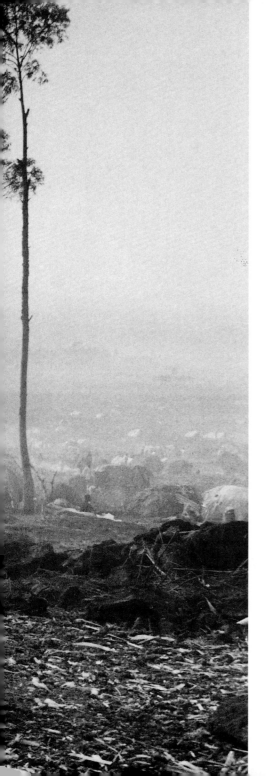

At the edge of hell. A teeming refugee camp in Kibumba, Zaire, just across the border from Rwanda.

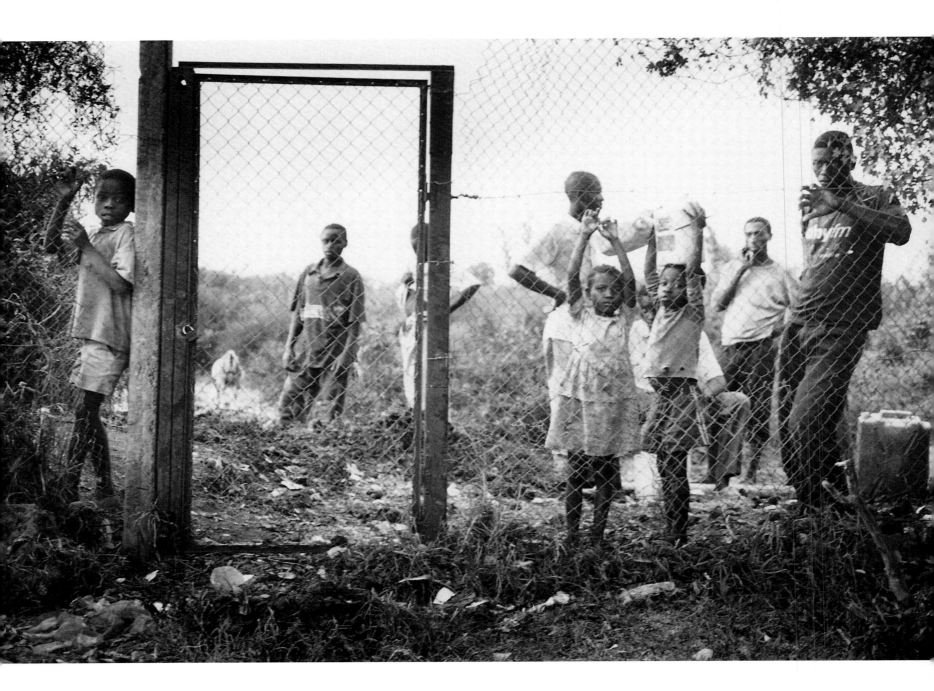

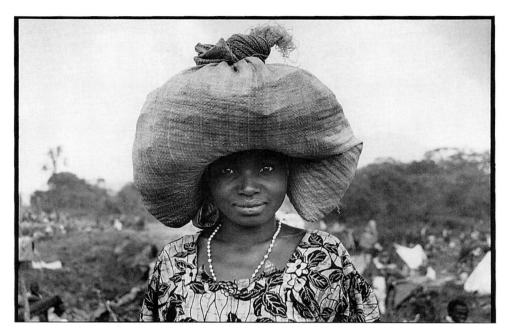

It was heartening to encounter youngsters
who were not sick, thanks to the
humanitarian aid that was getting through.

I spent the night in a UNICEF
encampment (opposite). At dawn, I took
my camera and wandered around shooting
pictures and came across this group of
refugees looking in.

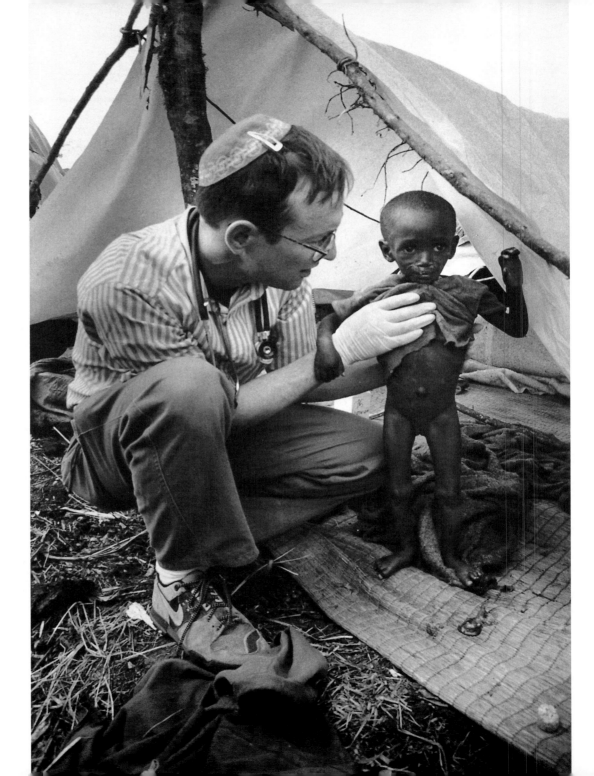

Dr. Rick Hodes, of the
American Jewish Joint
Distribution Committee. I did
what I could to help the
doctors as they went about
their rounds in the camp, but
the condition of the people
was so desperate that it was
like being on the front lines
after a battle.

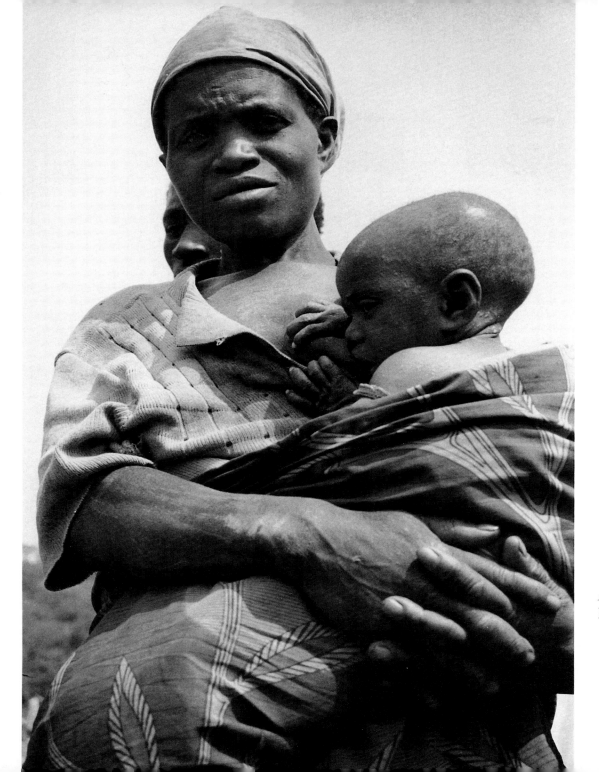

A mother nursing her child at Kibumba. Many mothers were too sick to take care of their children. Many other parents had been murdered.

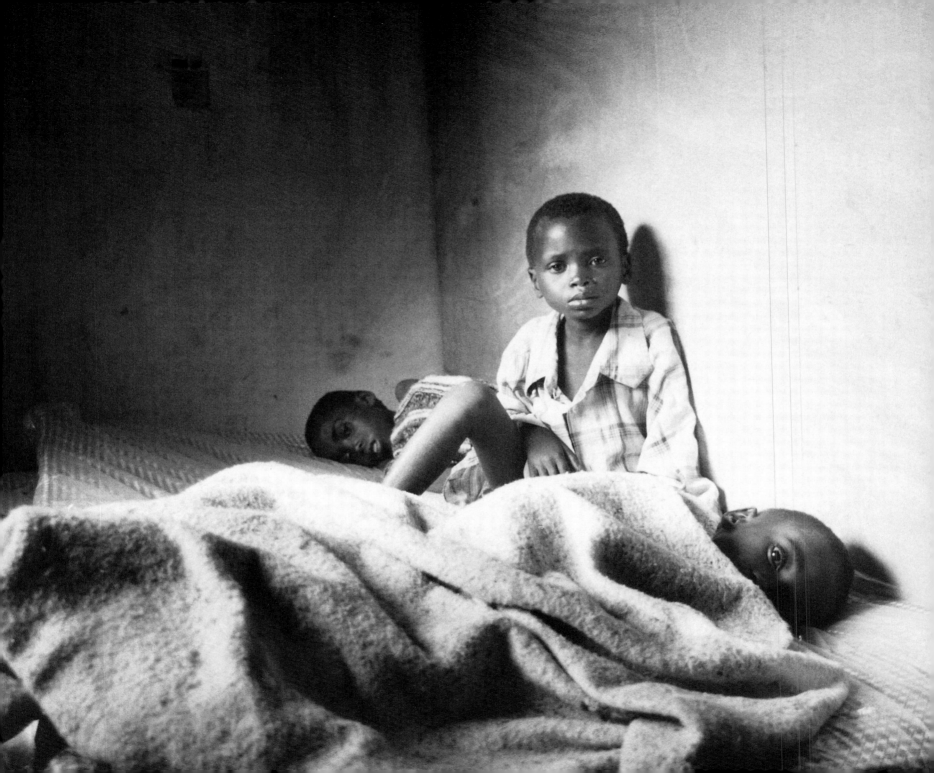

The real victims of the Rwandan
tragedy were the children. At the
time of my visit, UNICEF estimated
that there were 280,000 youngsters
whose parents' whereabouts were
not known. At the Goma
orphanage in Zaire, the younger
children all wore plastic
identification cards with numbers
on them. All of the children had
cholera and dysentery; sick as they
were, however, it was rare to find a
child who didn't respond to hugs
and expressions of love.

I've gotten to know a lot of homeless people in the course of my work as a volunteer with a group called Health Care for the Homeless. I go out in their van, which is equipped like a hospital clinic, and try to encourage the people we find in the parks or on the streets to get their medical needs attended to. It can take weeks, even months, before some people will trust you enough to let you help them. That was the case with Dwight, a homeless man I befriended. One day not long ago, he got arrested. When I arrived at the park, some of his buddies called out, "Hey, Tipper. Dwight wrote you a message." There on a sign, he had written, "Tipper Gore. Get Dwight out of jail." I couldn't do that, but I have been able to make a difference.

Jack is another friend of mine. I had been seeing him for years in Rock Creek Park, where he was often gathering brush on the hillsides. I used to call him the "Forest Man." When I began working with Health Care for the Homeless, I met him officially, so to speak. He was very shy, and it took a long time before he would accept help. He'd get in the van,

then jump right out. If we persuaded him to come back to Christ House, a residence for homeless men, for a shower or a meal, he'd walk out the minute he got there. Gradually, though, he began to come with us for showers and meals on a regular basis.

One day, I got a call from Pat Letke, one of the administrators, who told me she hadn't seen Jack for a while and she was worried about him. A few days later, on a Sunday, I found him asleep on a median strip while I was running in Rock Creek Park and asked him if he wanted to go to Christ House. He said, "Yes, do you have a car?" which is the most I ever heard him say at one time.

At Christ House they gave him a shower and were putting Kwell—a medicated shampoo—in his hair in case he had lice, when suddenly he bolted. The next thing I knew, he was running down the street, his hair standing straight up because of the Kwell, with me and my Secret Service agent in hot pursuit. He gave us the slip, and we were all very worried for fear of what the Kwell would do to his scalp.

Pat got the police to help her, and that night they

found Jack back on his hillside. Thanks to the Kwell, Pat could say that Jack was clearly a danger to himself, so they were able to take him into custody. For a while, he was in Saint Elizabeth's, a hospital for the mentally ill, where I visited him several times. Since then, he has started taking medication and has moved to a long-term residence, and he seems to be doing very well. One morning, he was cooking eggs to order for everyone!

Captain Kersh is another success story. He is a Vietnam vet who lived for many years in Farragut Park, not far from the White House. I got through to him by telling him that my husband had been in the Army Twentieth Engineering Brigade in Vietnam. I finally convinced him to move into Christ House for eight months. I also discovered that he was owed ten thousand dollars in back veterans' benefits, which is now being held in a trust for him. He was doing so well, they decided to move him into transitional housing at a place called Anchor Mental Health. But the prospect supposedly frightened him so much that he ran away the night before he was supposed to move.

Pat called me, figuring I would know where to find him. When I came across him in the park, I handed him a note I had gotten Al to write to him. It said, "Dear Captain Kersh, You should go back to Christ House and to Anchor Mental Health. This is a temporary housing solution for you. I am very proud of the progress you're making. Your fellow Vietnam veteran, Al Gore."

Later, in the car on the way to Christ House, he told Pat, "The Vice President of the United States, second in command of the whole country, is telling me I have to go to Anchor Mental Health. So I have to do it."

My philosophy in cases like this is, "Whatever works, do it."

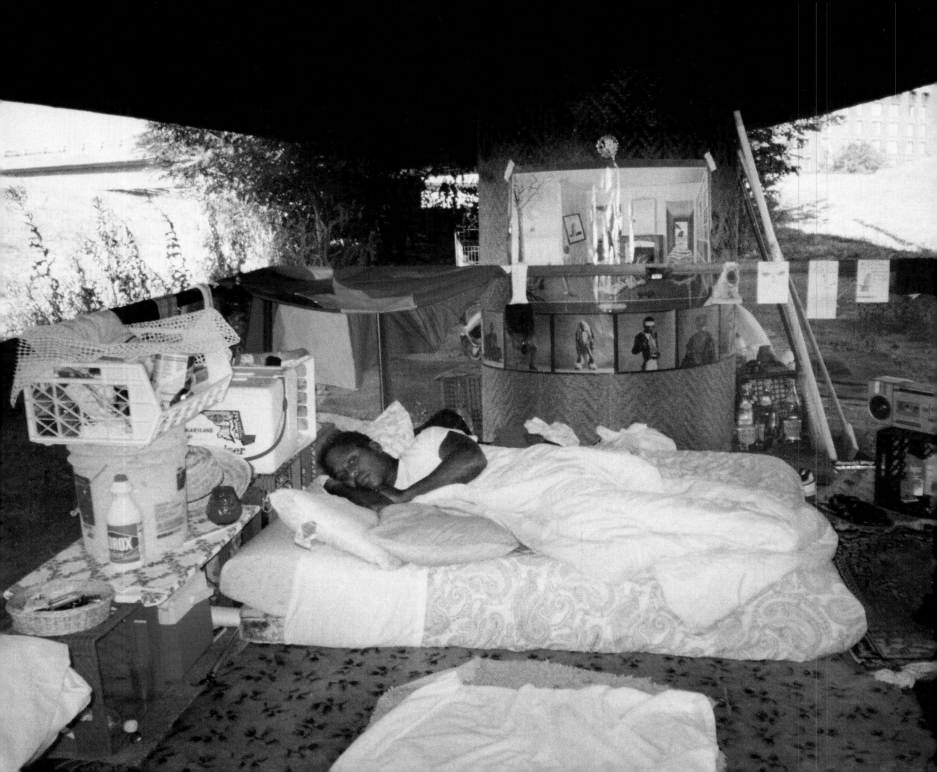

This man, called Brother, belongs to a
tight-knit clan of homeless people in
Washington who have formed a kind of
family, including a "mother," a "father,"
and two "brothers." The open-air shelter
they've constructed under the struts of
an overpass is immaculate, right down
to their bottle of Clorox.

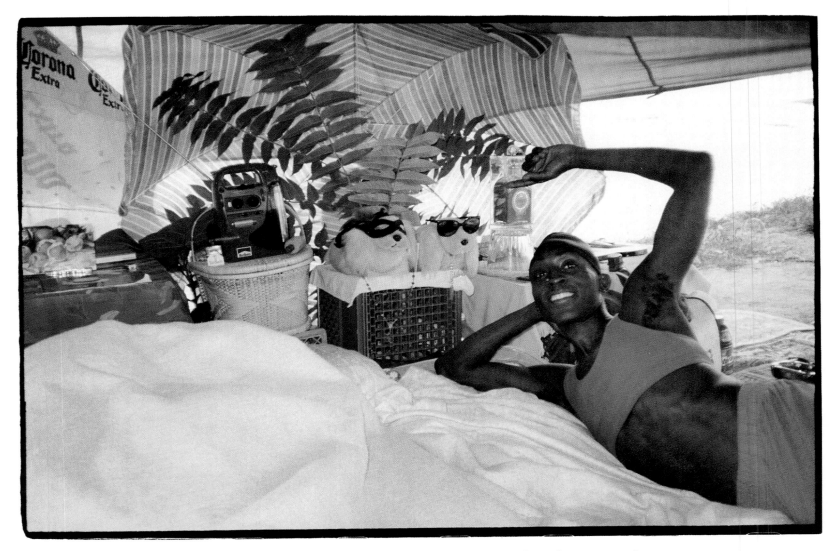

Diamond, one of the family members, points with pride to her possessions.

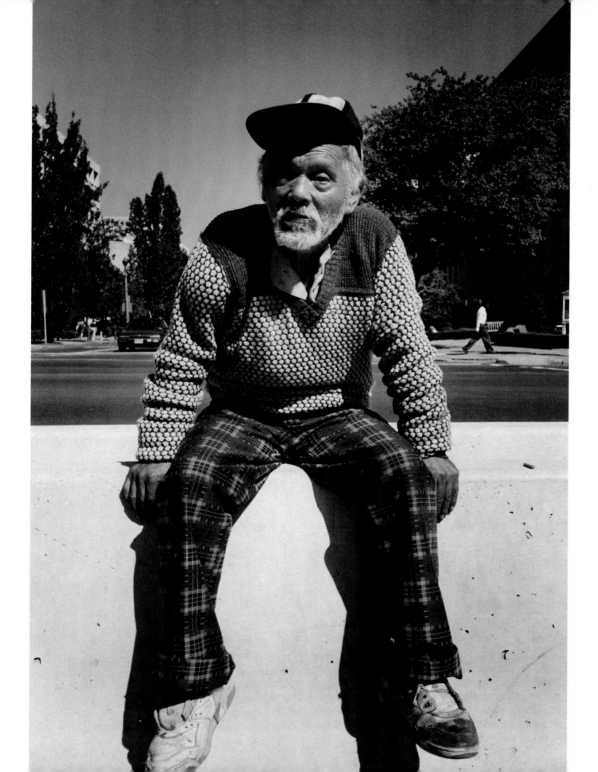

Despite his shyness,
Jack let me take this
photograph of him.

Private Time

For Al and me, there's no question that our happiest times are spent with family—just ourselves and our four children, and sometimes our parents. Although so much of our life is lived in public, but we are actually very insular. I'm afraid it's something some of our friends have a hard time understanding.

Al and I love to travel with our kids, but because of our busy schedules, it isn't easy to take vacations. I remember with particular fondness a trip we took in October 1993, when we spent a weekend in Camp Hoover in Shenandoah National Park. It was the first time since the election that Al and I and our four children had a chance to get away somewhere together.

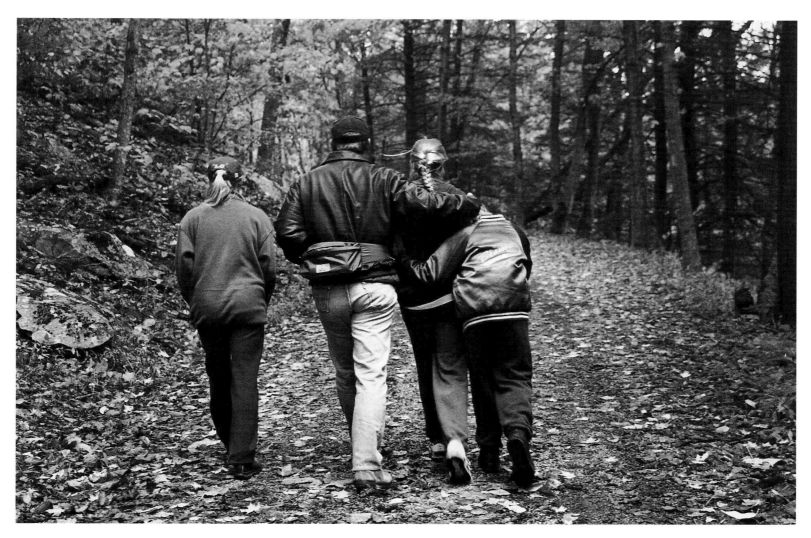

Solitude.

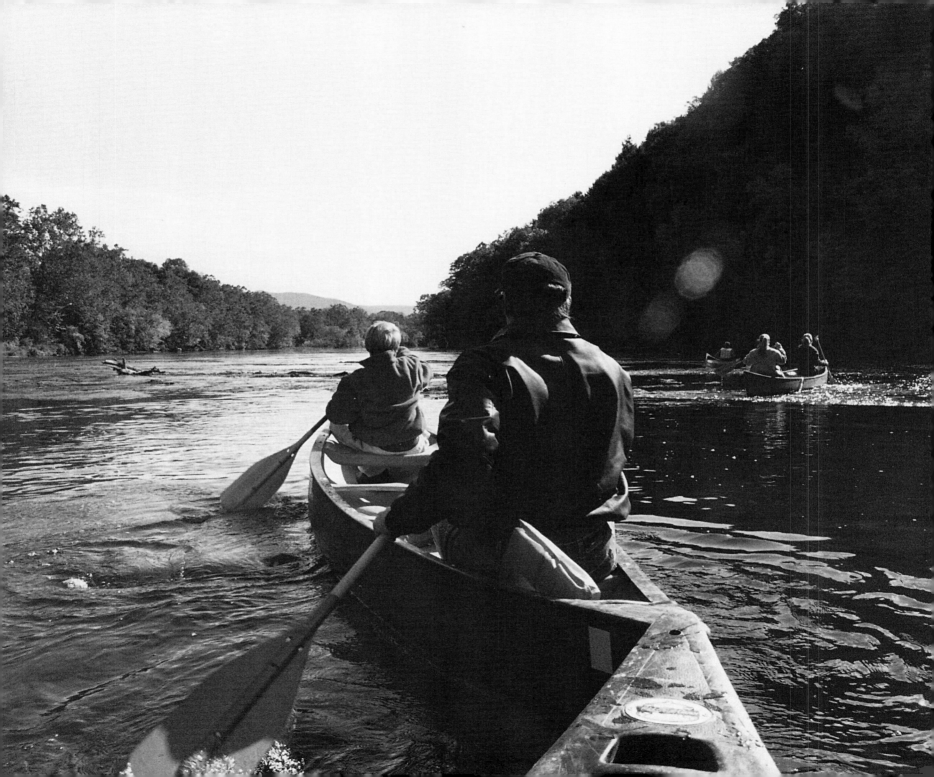

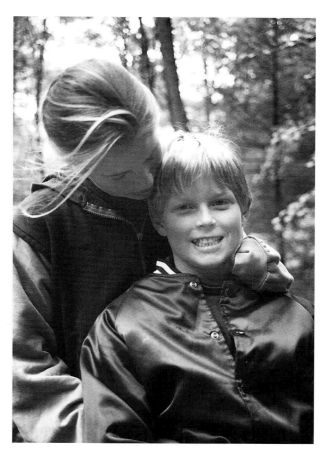

Kristin and Albert.

OPPOSITE: Canoeing at Camp Hoover.

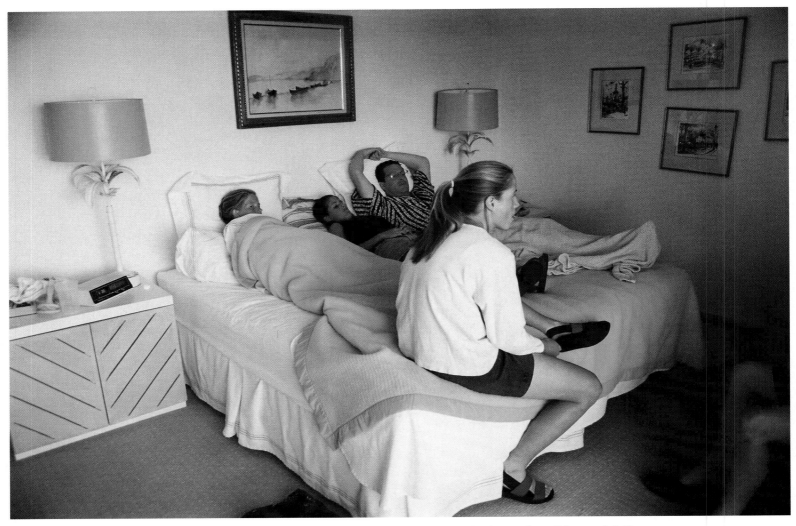

Kristin (seated) with Karenna, Sarah, and Al enjoying a lazy Memorial Day
weekend in Rehoboth Beach, Delaware, in 1993.

OPPOSITE: Albert and Al horsing around at the pool in Delaware.

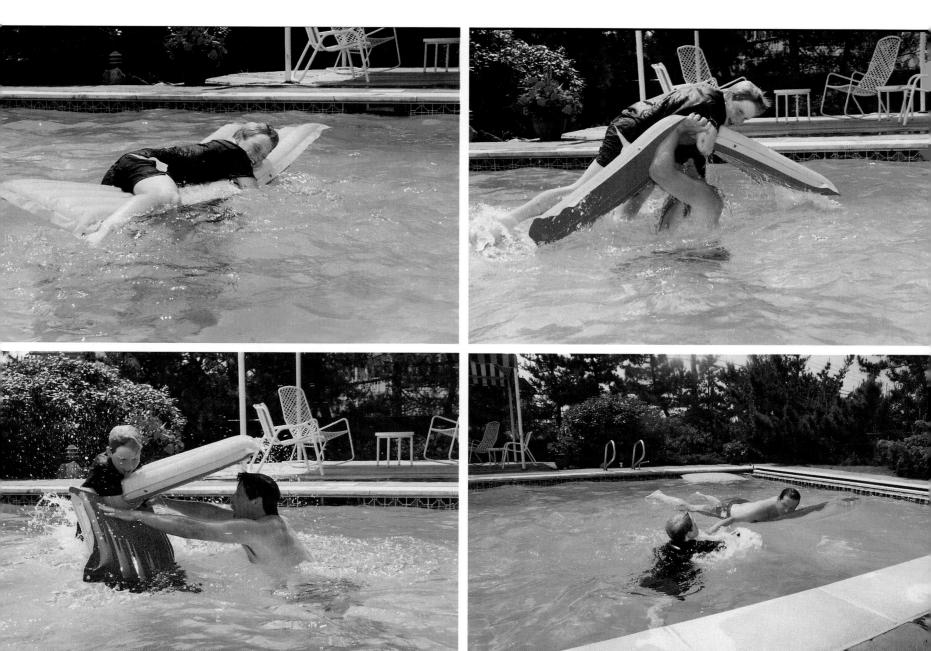

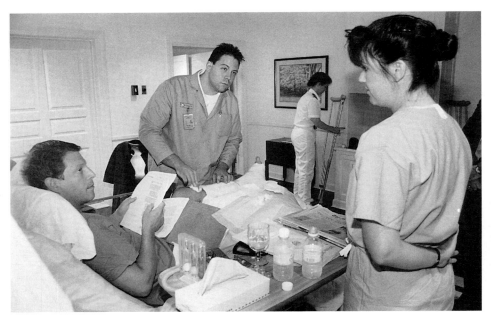

Al severed his Achilles tendon playing basketball in August 1994. It was a Saturday morning, and some of his old pals from Congress called and said, "It's been such a long time since you've played. Why don't you come down and shoot a few?" He likes to say he got the injury coming down off a "helicopter dunk." He came home limping badly, and I called the doctor, who put him in the hospital and operated that night. He was in a cast and on crutches for four months. In this photo, taken the morning after his surgery, Al is already back at work.

LEFT: Instead of going on a rafting trip down the Grand Canyon as we'd planned, we spent our vacation on a houseboat in Tennessee. Once in a while, we even got Al to stop working.

OPPOSITE: Al hobbling around the desert on a visit to Cairo, where he attended the world population conference in September 1994. His doctors were afraid his leg would swell inside the cast during the flight to Egypt and advised him against going, but he wouldn't hear of it.

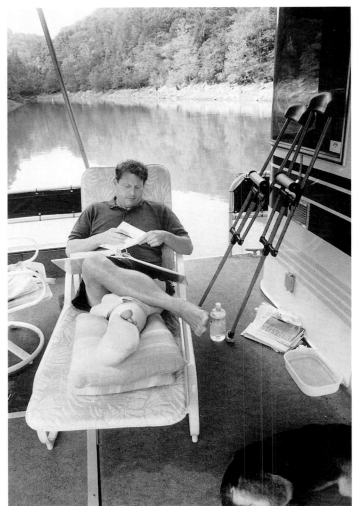

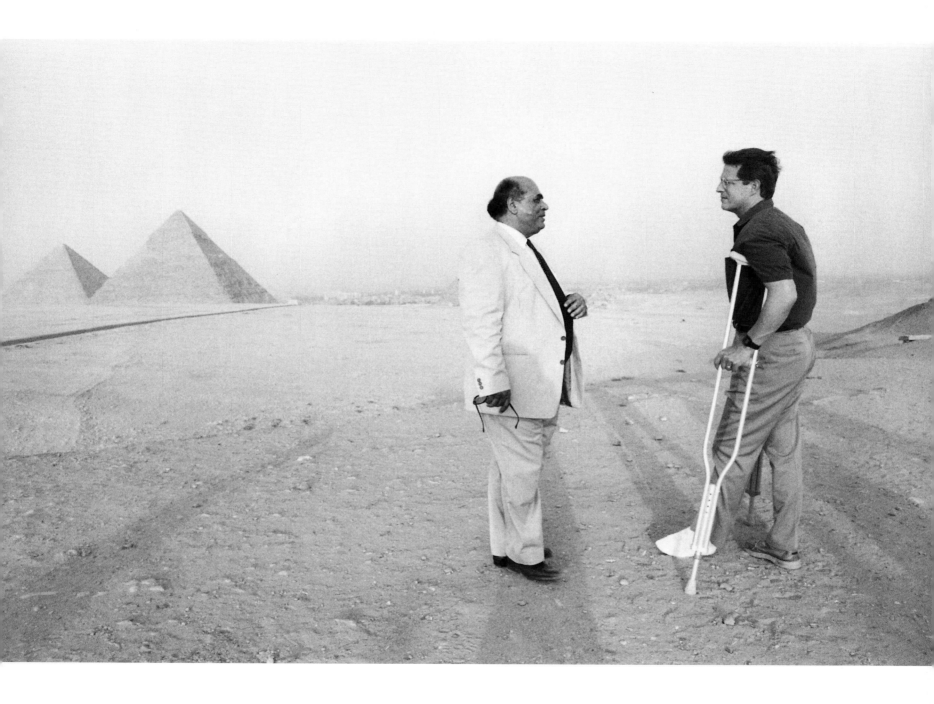

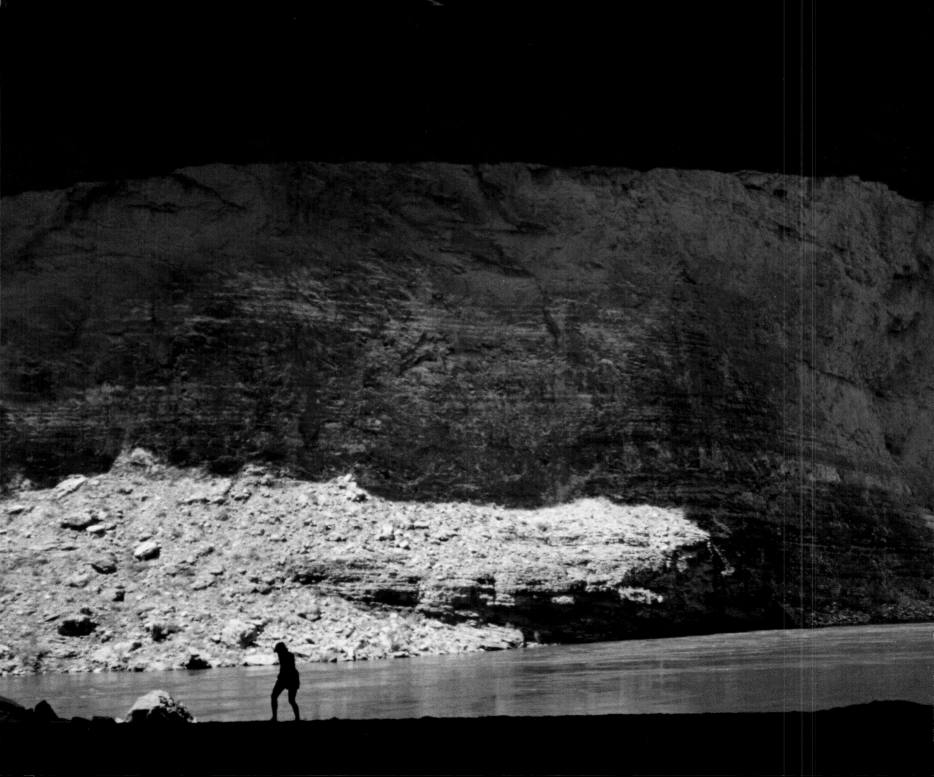

A year later than planned, we finally did
get to the Grand Canyon. The wildness
and solitude of the Canyon soothed our
spirits. We slept twelve nights under a
starry sky and spent the days fighting
the rapids. We were never happier.

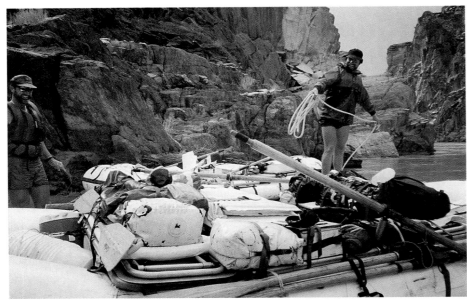

LEFT: Our gear, not including all the communications and security equipment we took along on our 225-mile rafting adventure.

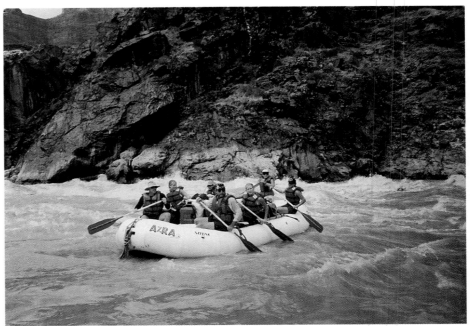

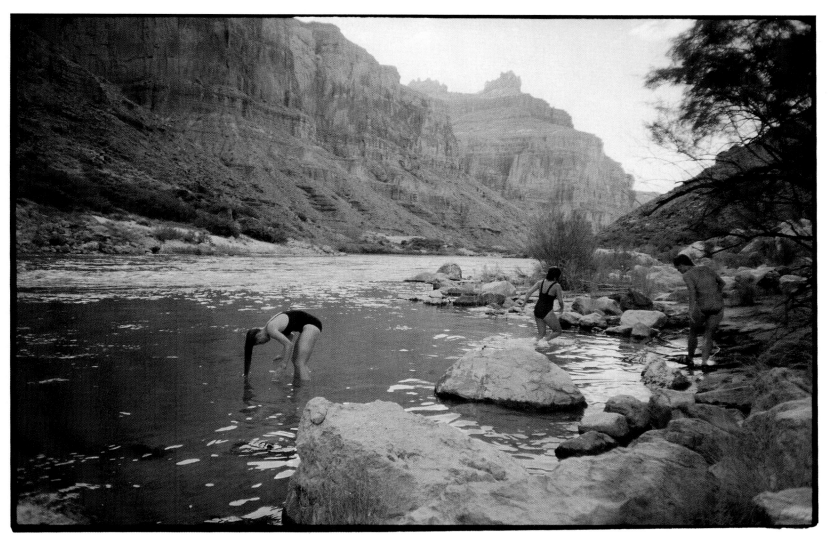

Kristin, Sarah, and Karenna take a bath in the only place available—
the Colorado River.

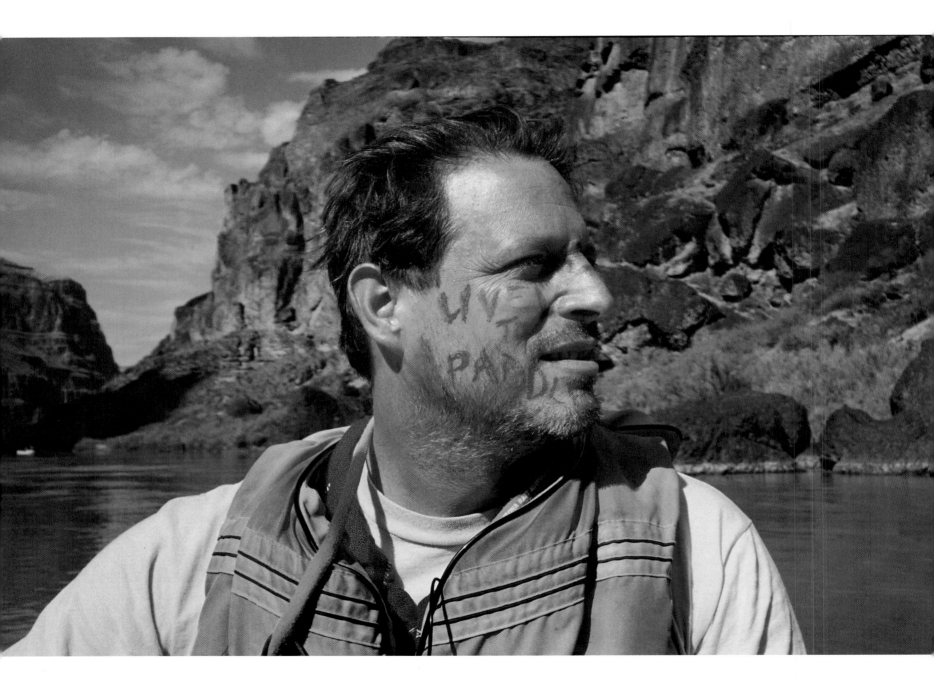

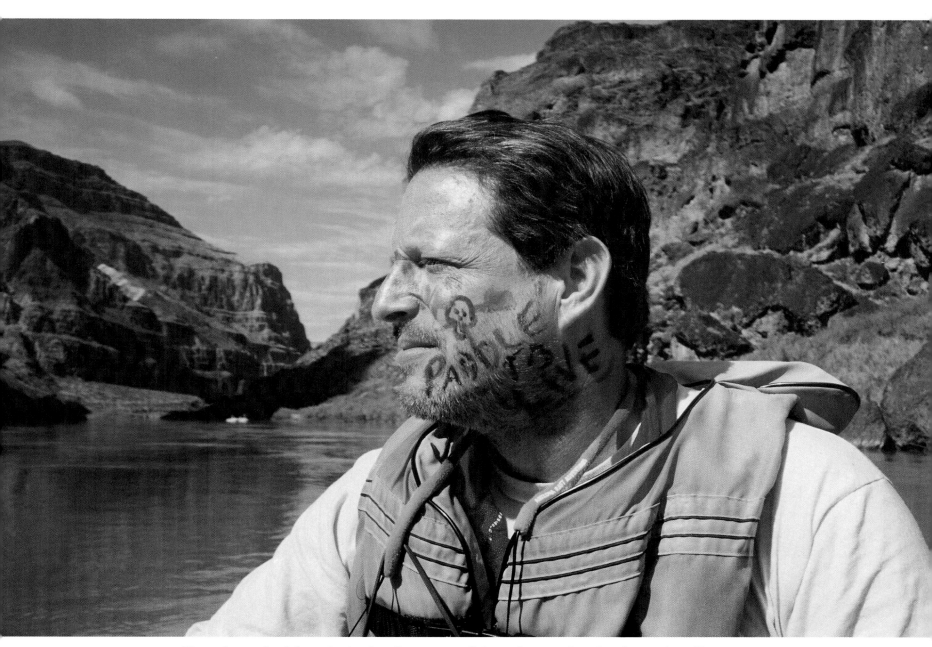

Near the end of the trip, in the Canyon tradition of preparing for the raging Class
Ten Lava Falls Rapid, Karenna painted good-luck mottoes on her Dad's face.

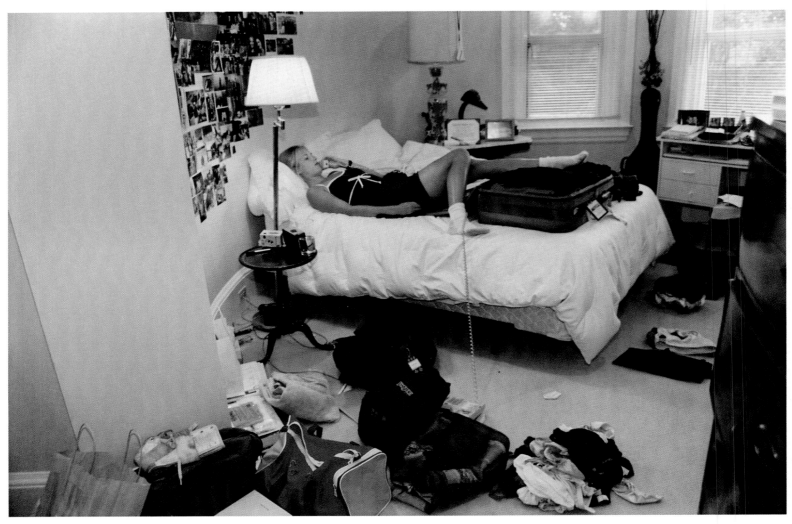

Kristin gets ready to go to college in September 1995.

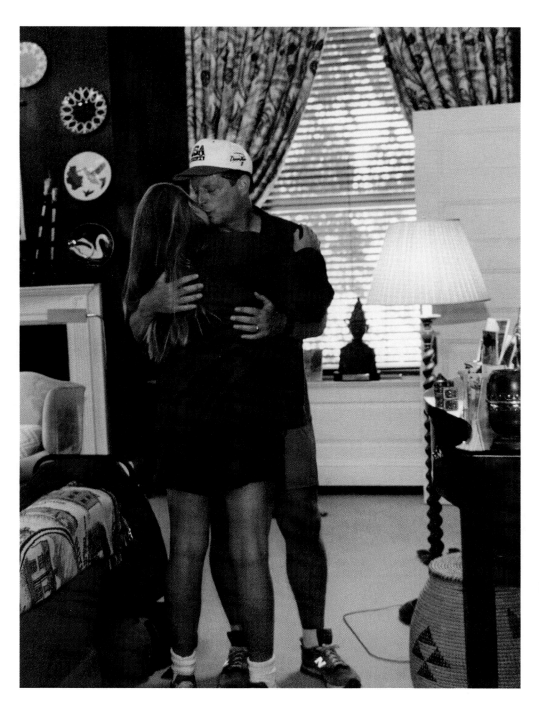

Al and Kristin say good-bye. I was feeling very emotional that day, because I had a sense of finality, knowing things would never really be the same. At moments like these, I like to do something active, and, in this case, taking pictures helped me deal with the sadness.

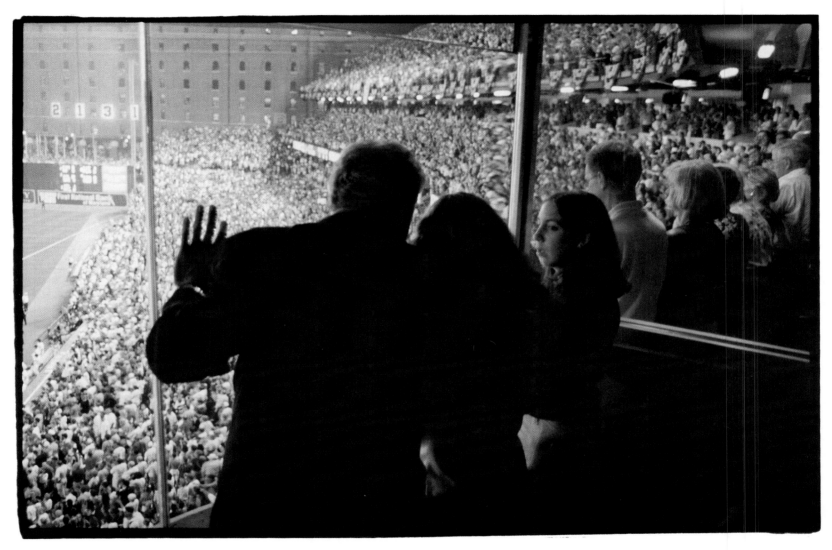

The President, Chelsea, and her friend Niki at Camden Yards, Baltimore,
just after Cal Ripken Jr. broke Lou Gehrig's record for the
most consecutive games played in professional baseball 2,131!

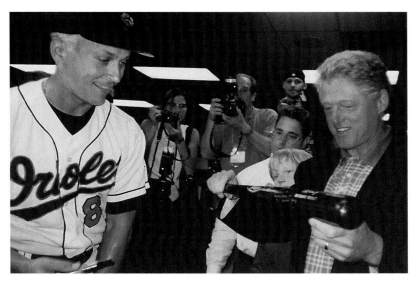

Cal Ripken signs a bat for the President. That's Albert, trying to get a peek.

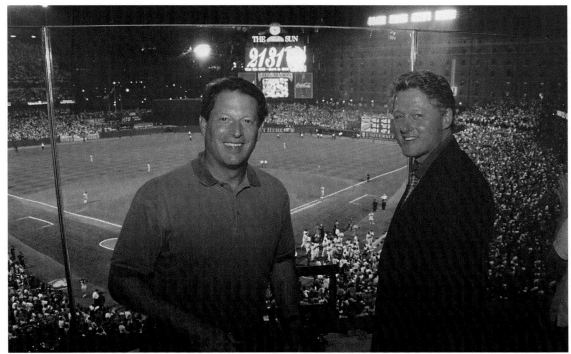

Two guys at a ball game. How American can you get? This was taken just after Cal Ripken's record-breaking game became official at the end of 5½ innings.

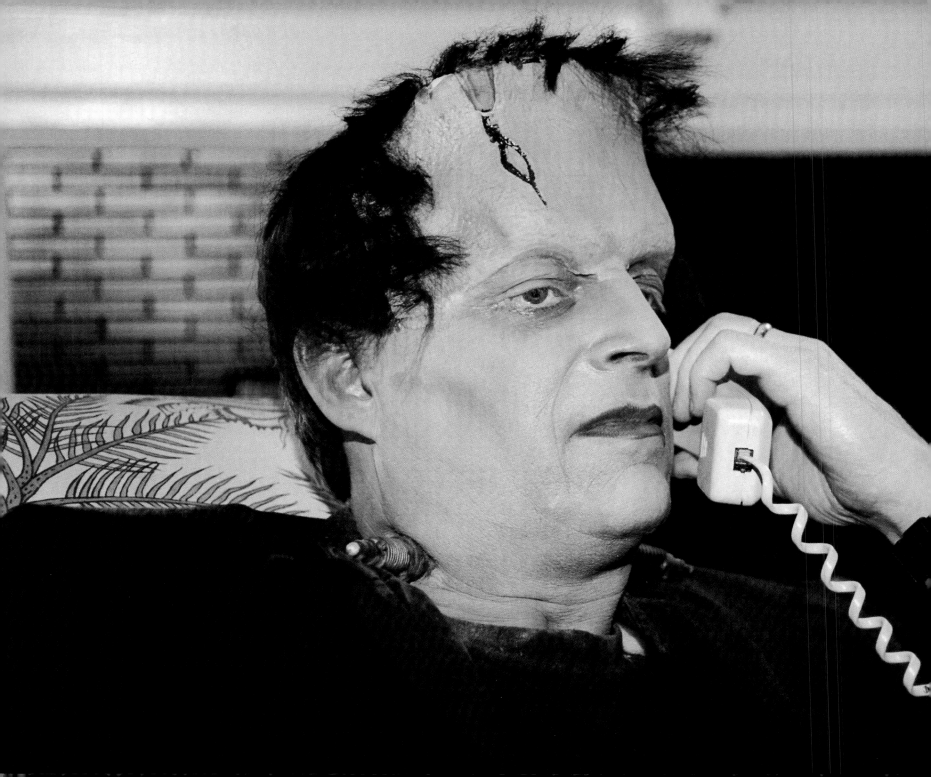

Frankenstein takes a phone call. Al and I
always throw a big Halloween party for
the press corps and their families. Here,
Al takes a moment away from the party
in 1994 to discuss some business.

113

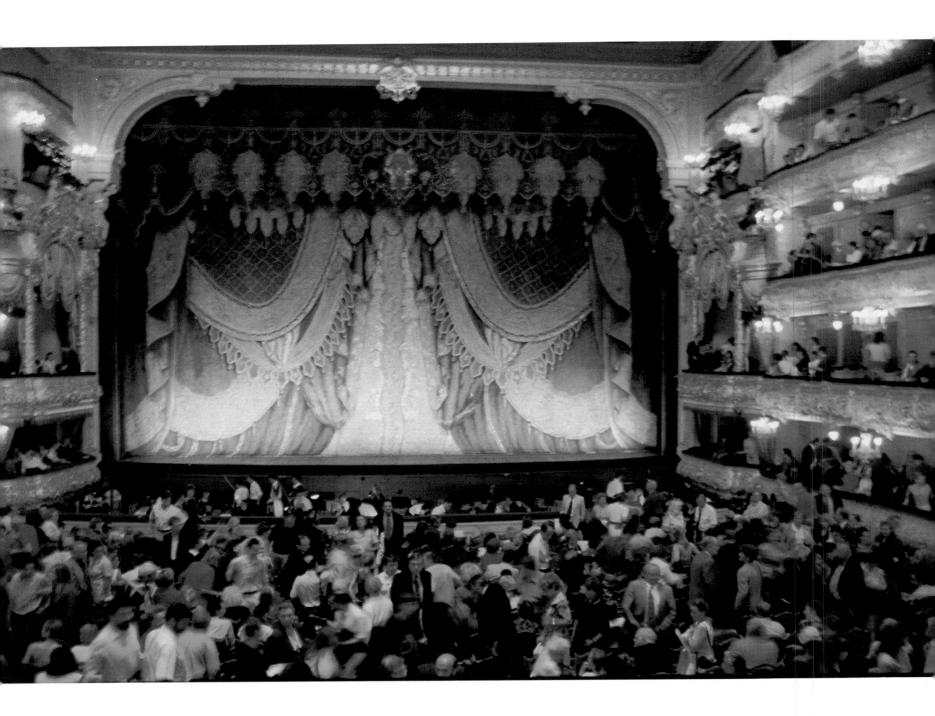

The Mariinsky Theater in Saint Petersburg
(opposite) buzzed with anticipation
before the curtain rose for the student
ballet. Afterward, the dancers
welcomed me backstage.

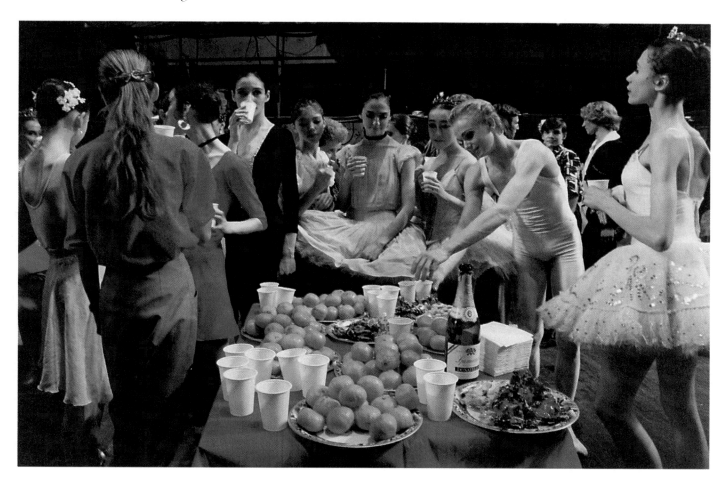

A bride and groom in Saint Petersburg. We met several newly married couples that day who were observing a Russian tradition of visiting national monuments on their wedding day. When I take pictures like this one, I always get the subjects' names and addresses and send them copies.

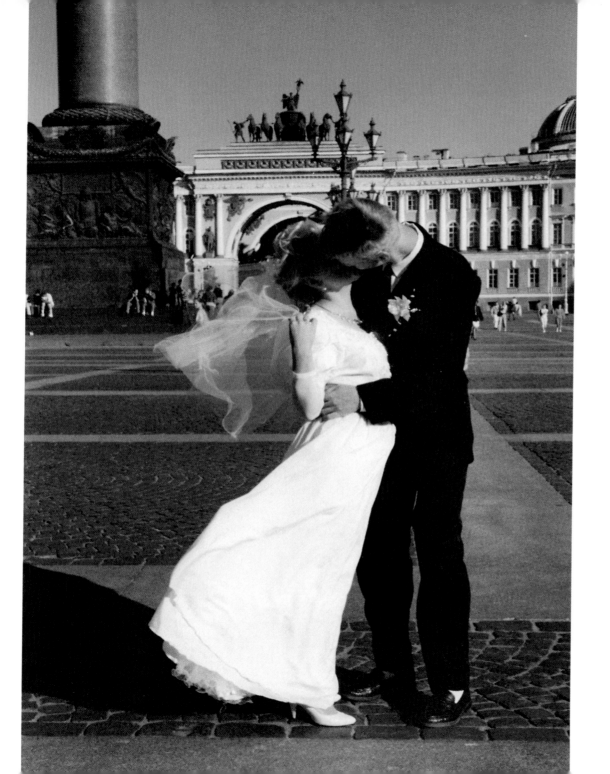

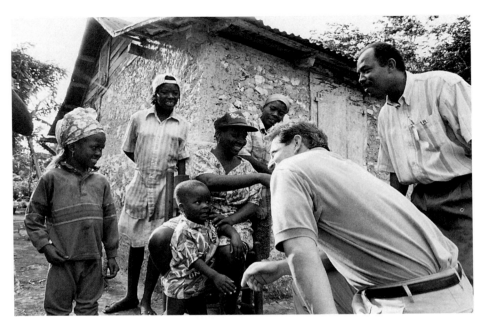

Cap Rouge, Haiti

In October 1995, Al traveled to Haiti with a group of environmentalists to talk to Haitian government officials and coffee growers about an Agency for International Development reforestation project. The forests in Haiti are devastated beyond belief. When you look down from an airplane, you see miles and miles of red clay, devoid of any trees. Just across the border, in the Dominican Republic, it's lush and green.

OPPOSITE: Villagers in Cap Rouge.

122

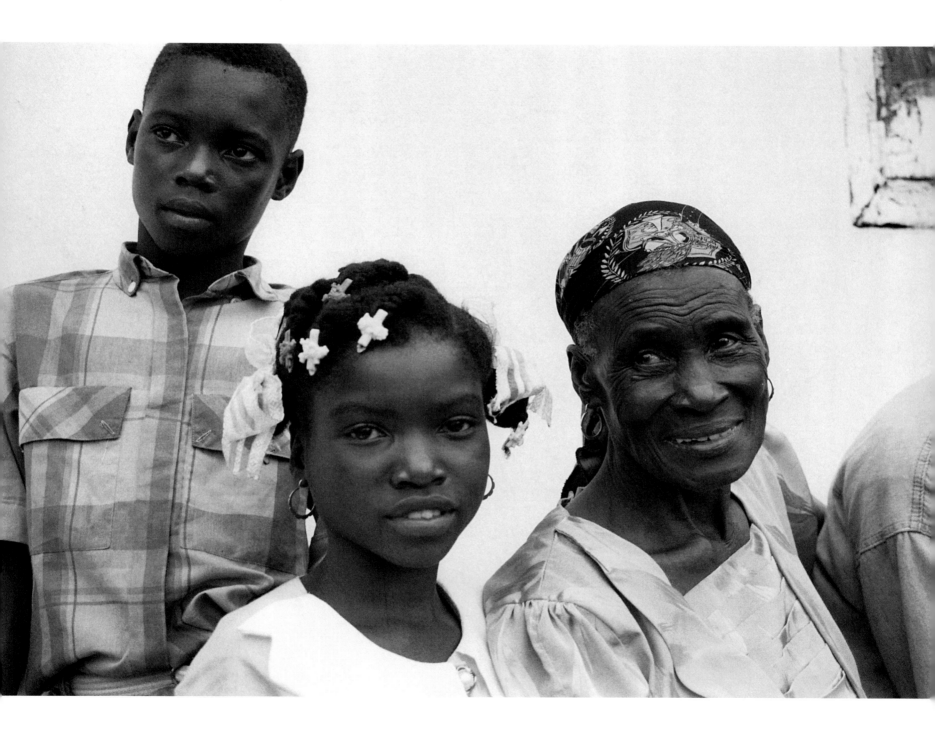

I visited a nutrition center in a hospital in Cité Soleil, one of the poorest neighborhoods in Port-au-Prince. This little girl looks healthy, but she isn't. Her cheeks are swollen with a condition called kwashiorkor.

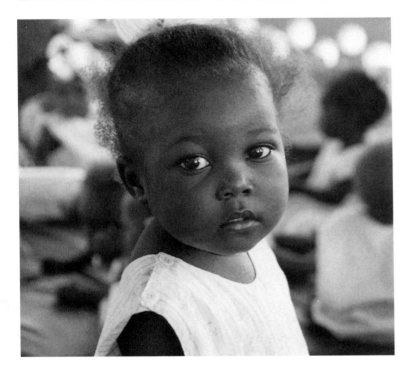

This is the way the children look after getting treatment at the center, which is a highly successful U.S. AID program. In addition to feeding the children, the program teaches parents about proper nutrition and provides job training.

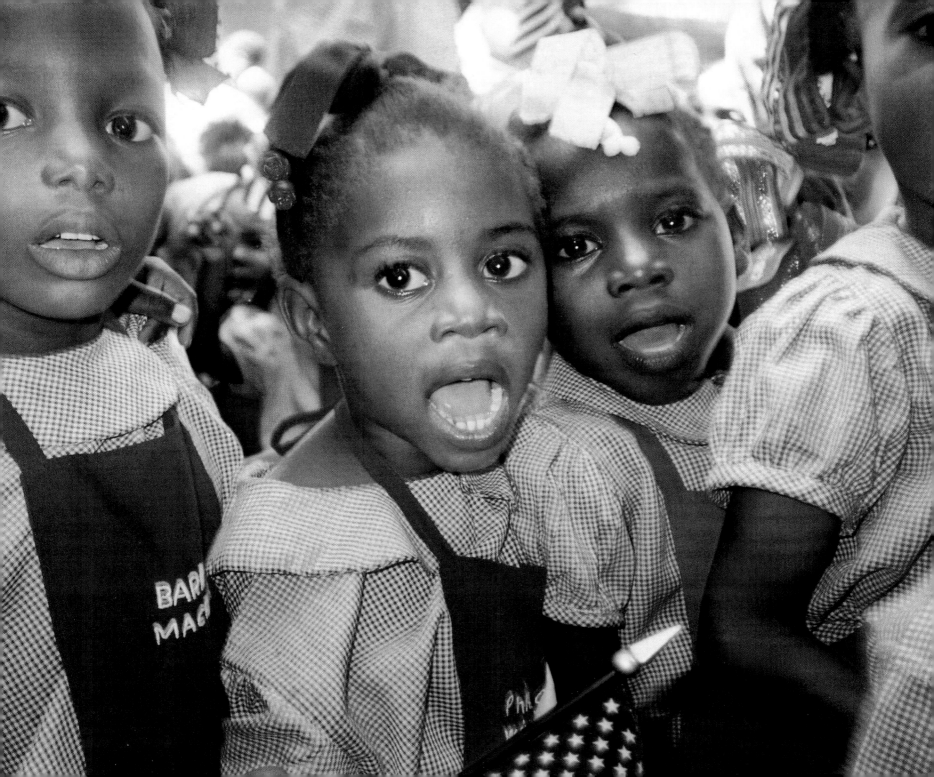

On our South American trip, we were
greeted warmly everywhere we went.
Here, Bolivian children welcome us in
Huatajata, a remote village on the
shores of Lake Titicaca. It is the
hometown of Lydia Cardenas, the wife
of the vice president of Bolivia—
the first Aymara Indian to hold such
a high position in the country.

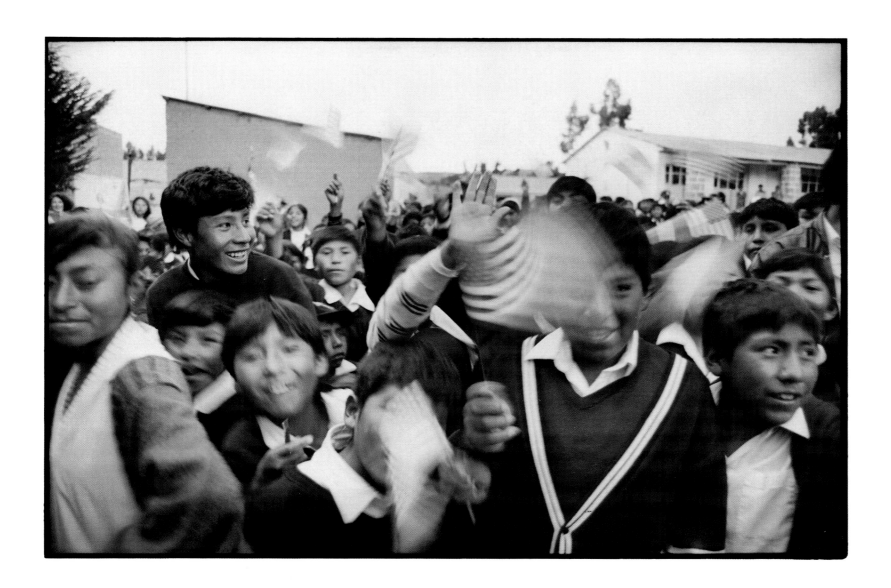

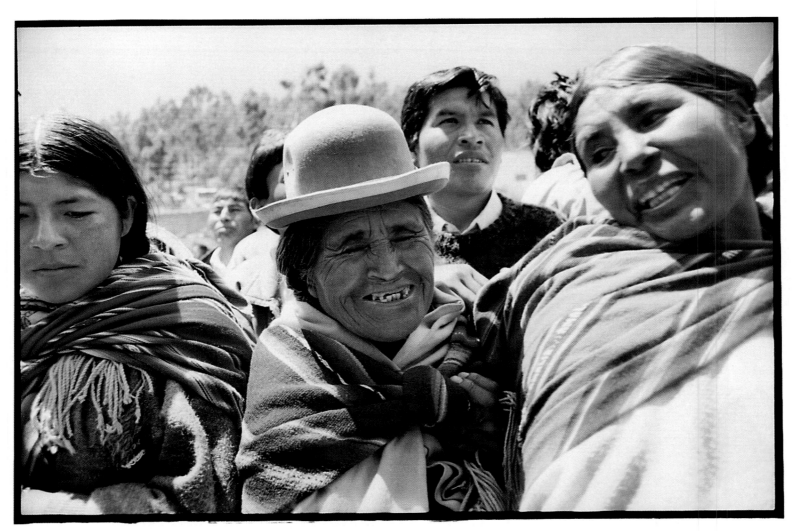

The townspeople of Huatajata, unaccustomed
to receiving government delegations, were
thrilled with our visit.

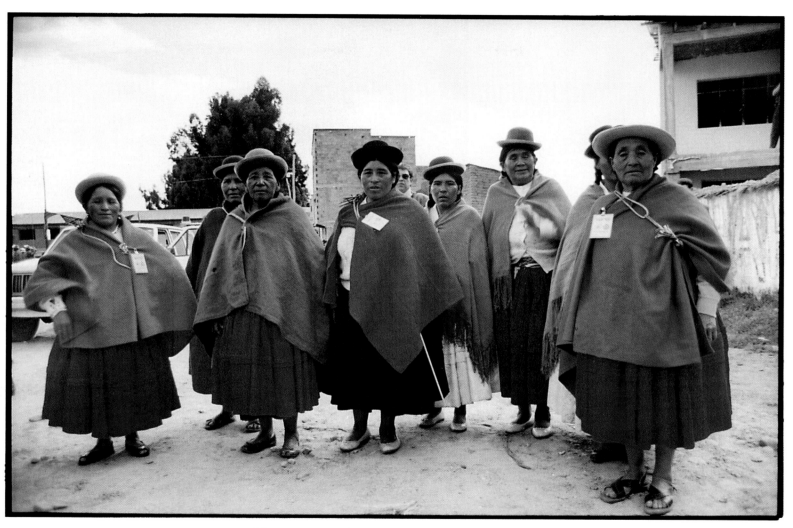

The women of Huatajata in traditional
Bolivian dress.

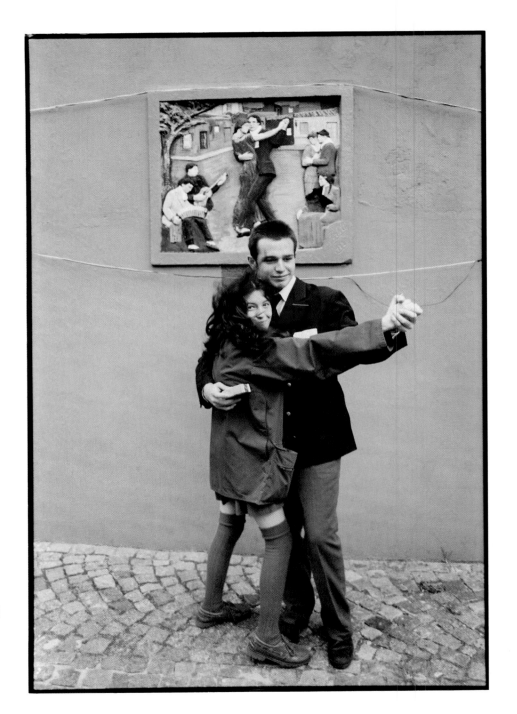

Students ham it up in front of a bas-relief in La Boca, a poor but picturesque district in Buenos Aires. Many artists live there and have decorated the buildings and streets with their paintings and sculptures. An etching I bought on the street now hangs in my bedroom.

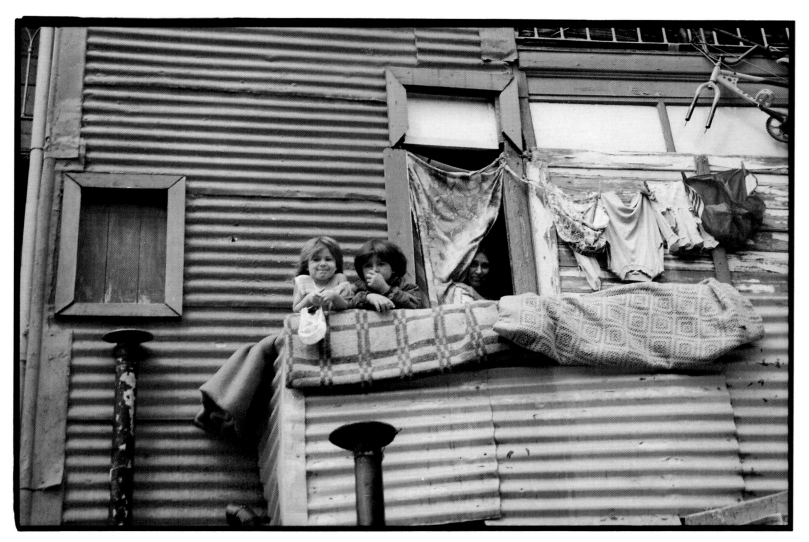

The houses in La Boca are made of pressed tin
and are painted bright colors using leftover paint
from a nearby shipyard.

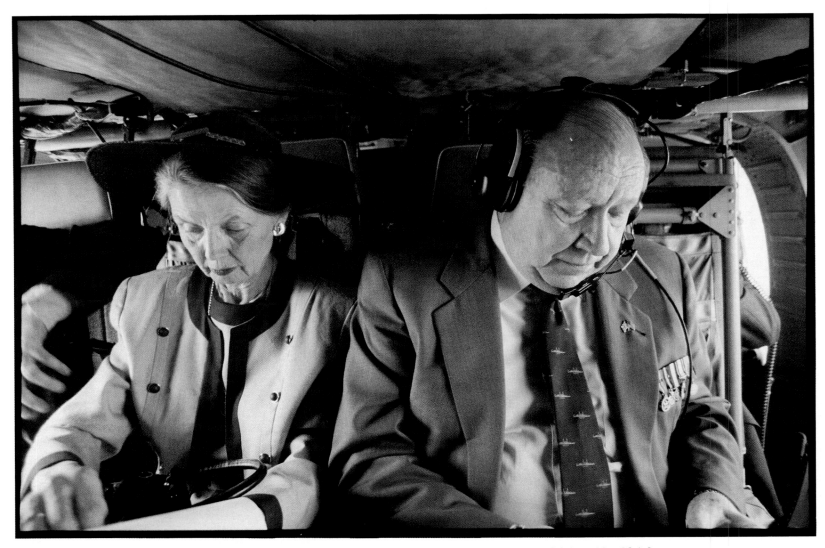

U.S. Ambassador to the United Kingdom William Crowe and his wife, Shirley,
aboard a helicopter. We traveled to England in May 1995 to commemorate
the fiftieth anniversary of the end of World War II. We stayed with the Crowes
at the ambassador's residence in London.

A grave site at Cambridgeshire, a cemetery where Americans who died in World War II are buried. My brother-in-law, Frank Hunger, left this packet of documents at the grave of a fallen American at the request of family members in Mississippi. I took the picture to show them their wishes had been carried out.

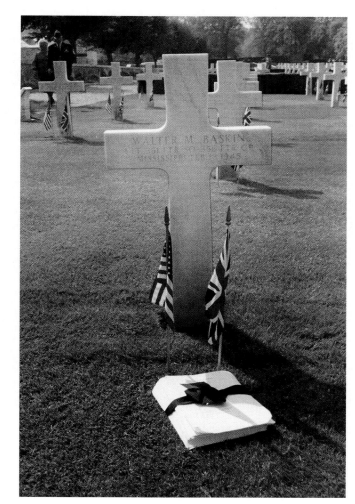

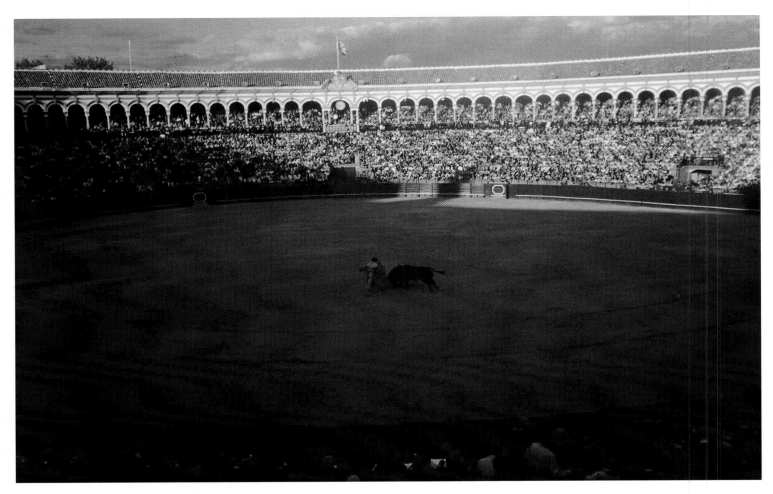

On a trip to Spain in April 1996, I saw my first bullfight.
To the Spanish, bullfighting is an art form.

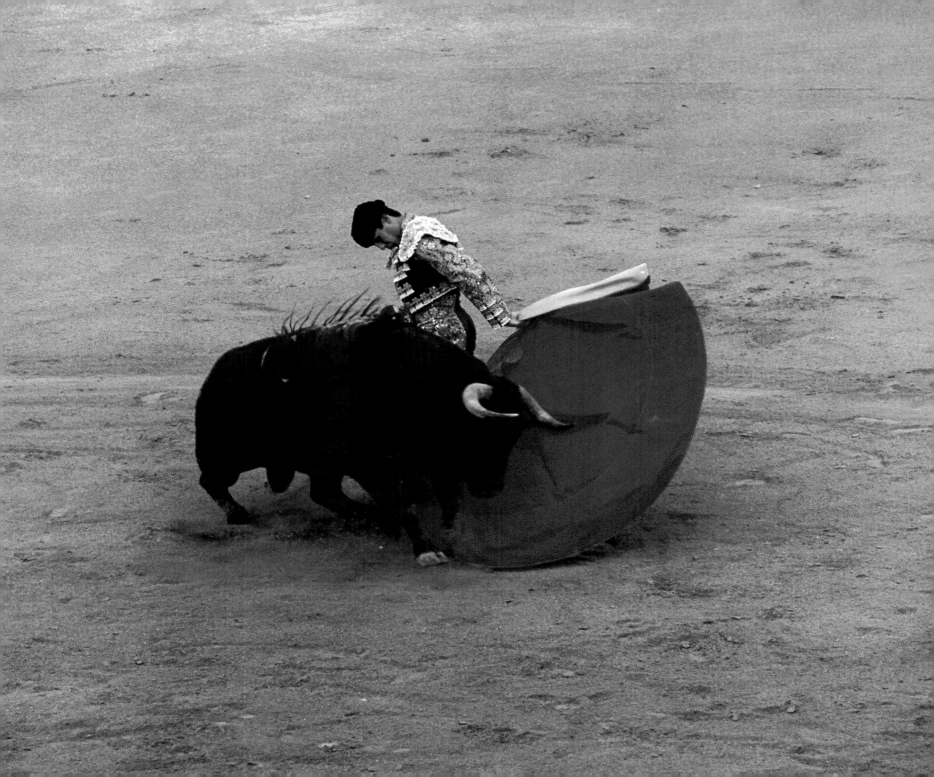

The world flashes by when I'm on official travel. While I'm taking pictures, I often don't have time to wait for the right light or for the subject to change position. Because I'm in motion, too often a quick glimpse is all I get. These are some of my favorite fleeting moments.

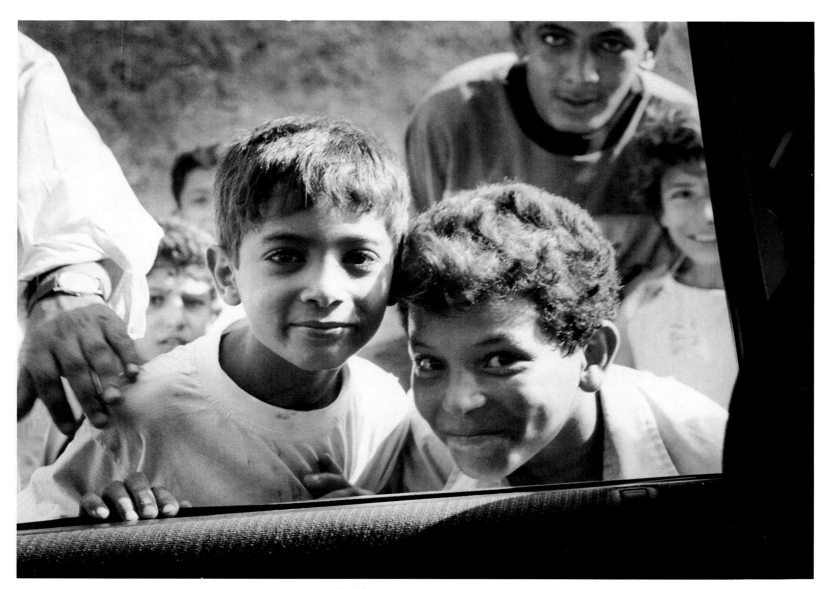

Children in Cairo, Egypt.

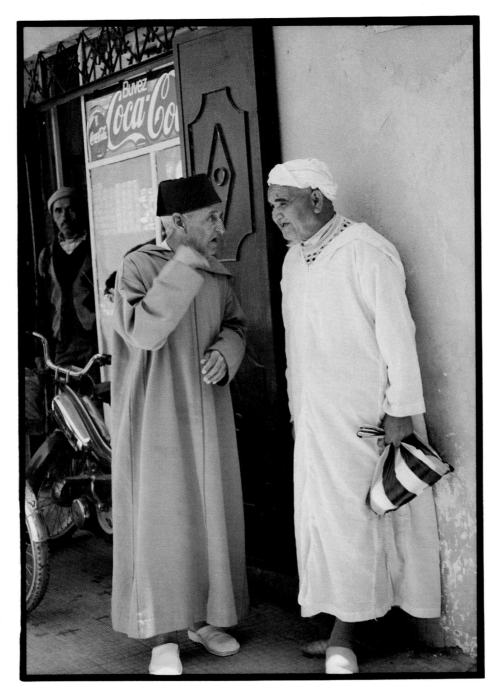

Friends gossiping in
the marketplace, or
souk, in Marrakech,
Morocco.

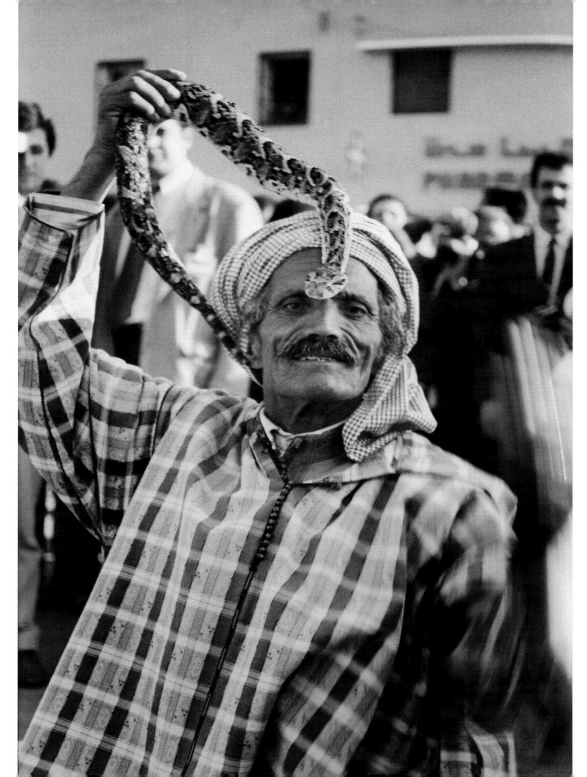

Snake charmer
in the souk in Marrakech.

Cairo

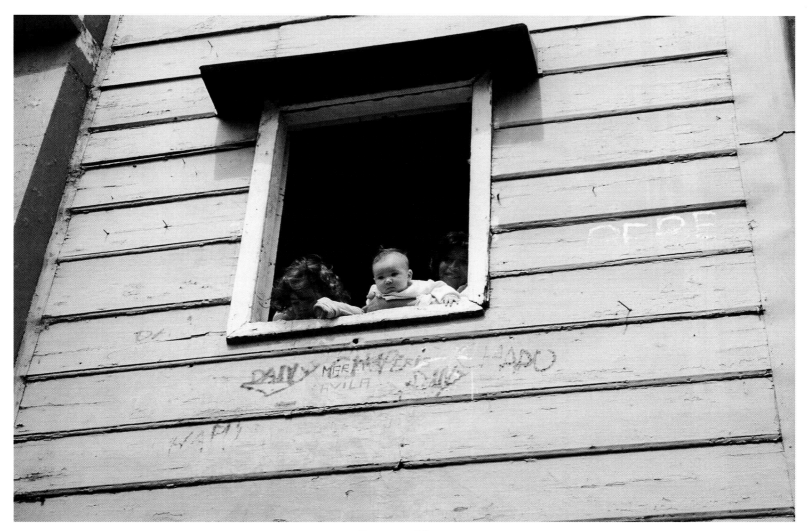

Buenos Aires

Shooting back at the press goes global. Dueling cameras in Moscow's Red Square, Buenos Aires (below), and Oman (opposite).

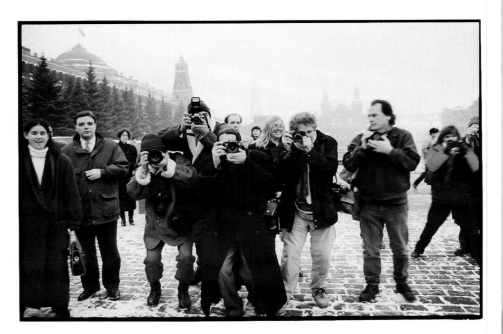

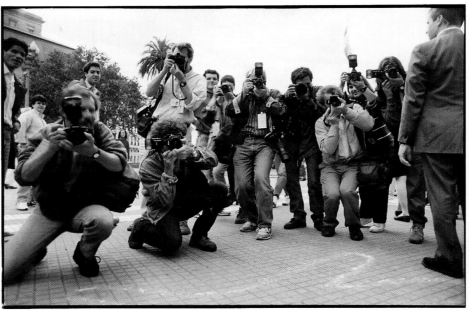

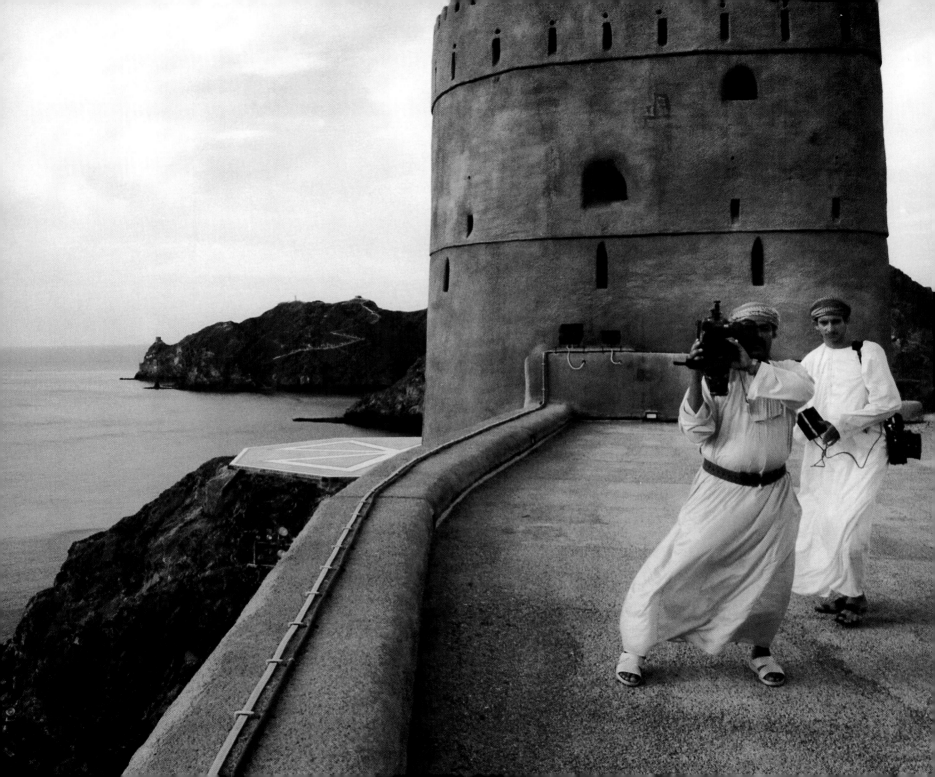

A Celebration of Family

We try to go back to our farm in Carthage as often as we can. For us, it's a place with many wonderful associations. We bought the farm, which is just across the river from Al's parents, when we first got married, and we lived there full-time for several years. I was a farm wife in those days. Al was going back and forth to Nashville, which is fifty miles away, and I took care of the children, the house, and the garden. I was very domestic. I made the drapes for our dining room and refinished a lot of our furniture. I planted the garden, which was quite large, by myself. Farm life suited me just fine.

These days, Carthage is the place where we go to relax and unwind and be with the family. The children love it because it's just the six of us plus their grandparents, with whom they are very close.

We try to go down there on special family events like birthdays, Thanksgiving, and Christmas.

Christmas in Carthage is a real tradition in our family, but it requires some fancy logistics—things like trimming two trees and shipping packages ahead. One year I suggested we might try staying in Washington, but the kids wouldn't hear of it. They promised to do everything—shop, clean, and cook. And they did. They came back from the grocery store with a twenty-pound turkey and cooked it to death, but we didn't say anything, because we wanted to encourage that kind of responsibility.

Carthage is one place where I can relax and have the luxury of time and the peace of anonymity. It's also where I combine my two greatest loves, family and photography.

Albert Gore Sr. chopping down our Christmas tree in
Carthage, Tennessee. According to tradition, only Al, his
dad, and the four children go on the Christmas tree
expedition, but one year I was invited to take a picture.

Karenna, Albert Gore Sr.,
Pauline Gore, and Albert on
Christmas morning.

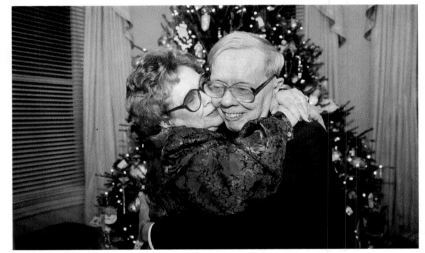

My mother, Margaret Ann
Aitcheson, and her longtime
friend Ward Hussey, at a
Christmas party in the
Residence.

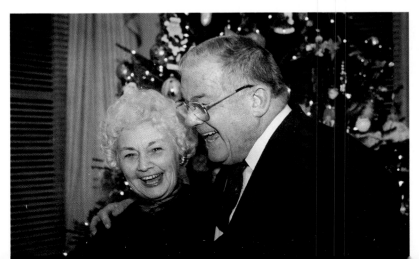

My dad, Jack Aitcheson, and
his wife, Barbara.

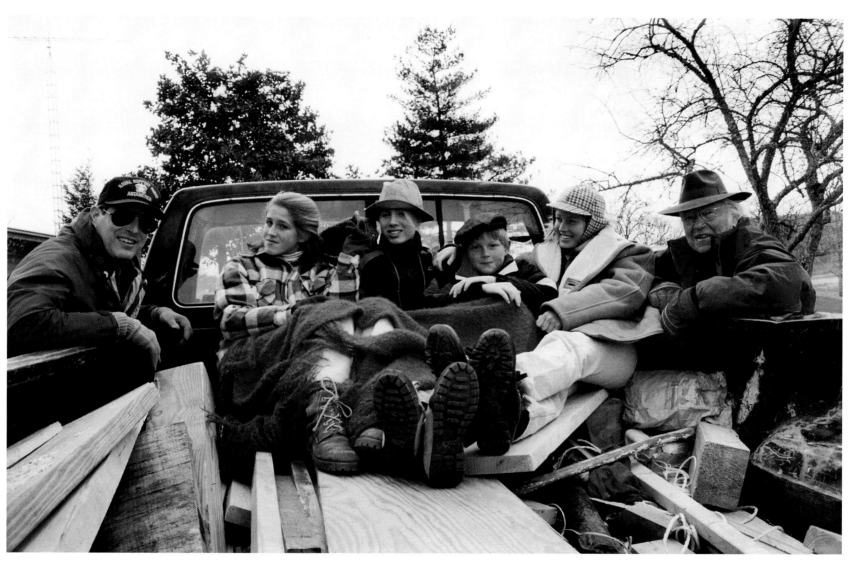

Al, Sarah, Kristin, Albert, Karenna,
and Albert Gore Sr.

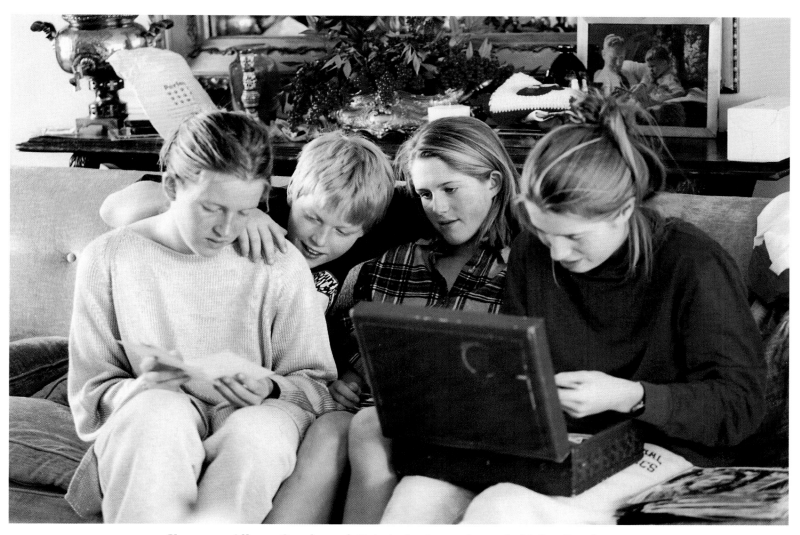

Karenna, Albert, Sarah, and Kristin look at a box of old family photos.

Acknowledgments

This book made the journey from my mind to your hands largely because of my publisher John Sterling. We originally became friends when he edited my husband's book *Earth in the Balance*. Years later, as I began to see my dreams emerge, the first person I called to share my idea with was John. He had the vision. He had the faith. And now he has a grateful author. Thank you, John, for believing in me.

Taking the photographs was the easy part of this book. Crafting the words was not. Often I knew what I wanted to say, but just didn't know exactly how best to say it. So I called on Barbara Matusow for help. Only a kindred spirit and talented writer like Barbara could have strengthened my voice and put it into words that reflected so skillfully the strong emotions I was struggling to express. Barbara spent hours listening to me and then wove my story together beautifully. I am grateful for her skill, her insight, and her patience.

The gifted picture editor and photographer Molly Roberts gave this book much of its character. She looked through thousands of images and her sensitive eye and soul helped me craft the story I wanted to share. There are no appropriate words to express my gratitude to Molly—I'll give her favorite photograph to her instead!

Many others were important to the creation of this book. They have earned my lasting gratitude and deserve a special mention:

Jodi Cobb, my longtime friend and source of personal inspiration, who helped guide me through this process every step of the way.

Gayle Bauer, a fellow volunteer, who shares my love of photography and selflessly gave hours to this book and all my other photography projects over the last four years.

Nancy Rhoda, who taught me the basics of photography and who encouraged me more than anyone else other than Al. Nancy and I became friends in an unlikely locale: her basement darkroom in Nashville, Tennessee. She taught me to print negatives, and it was the beginning of a beautiful friendship that has lasted for years.

Jack Corn, my first photography teacher and boss. His insight and professionalism have influenced both my life and my pictures, and for that I thank him.

Liza McClenaghan, whose friendship and assistance have made many good things possible.

Ruth Goltzer, whose organizational talents and friendship have gotten me through so much.

Amy Gilbert and Susan Haessler, who provided valuable assistance while I was working on this project.

A special thanks to Skila Harris, whose judgment has kept me focused, whose perspective

has kept me grounded, and whose good humor has kept me laughing. A special thanks also to Sally Aman, whose energy, friendship, and commitment have enriched my experience and brightened my memories.

For their help at home, tons of thanks and praise go to Philip Dufour, Bill Althoff, Jeff Reed, John Hester, Don Trelstad, Al Ramirez, Ed Dreher, Michael Pant, and Ann Williams, all of whom have made it possible for me to devote my time to my family, the causes I care so much about, and this book. You share the credit for many good things that have happened over the past four years.

Another important person on the home front has been Amy Melvin. In addition to everything else, I thank her for the endless hours she spent sorting through negatives and prints in search of just the one I wanted.

Many thanks also to everyone at Broadway Books, especially Trigg Robinson, Marysarah Quinn, and Rebecca Holland.

Some of the most memorable experiences and photographs I share in this book feature President Clinton, Mrs. Clinton, and Chelsea. I hope I captured the warmth and the strong kinship that binds us.

They have been wonderful friends with whom our family has shared this historic journey, and I am grateful for the way they have embraced and supported me and for their gracious indulgence of yet one more photographer!

I am blessed with a wonderful family who brings great joy and meaning to my life. My mother, Margaret Ann Aitcheson, and my father and stepmother, Jack and Barbara Aitcheson, are an endless source of love, understanding, and perspective. In addition, for over twenty-five years, my life has been enriched by the love and support of Al's parents, Albert and Pauline Gore, and our brother-in-law, Frank Hunger. I cherish the family we've all become.

A loving tribute goes to Karenna, Kristin, Sarah, and Albert—one-time reluctant subjects who became willing participants for a cause close to all our hearts. In a way, children are like photographs. You're never entirely sure how they'll turn out. But these four, I'm happy to say, have turned out magnificently. And as they continue to develop, I'll continue to gaze upon them with unspeakable awe and a love that knows no limit.

And, finally, I am forever grateful to my husband, Al, for the respect and appreciation he has for me and my interests. His constant support inspires me and his love sustains me.